THE BERKSHIRES

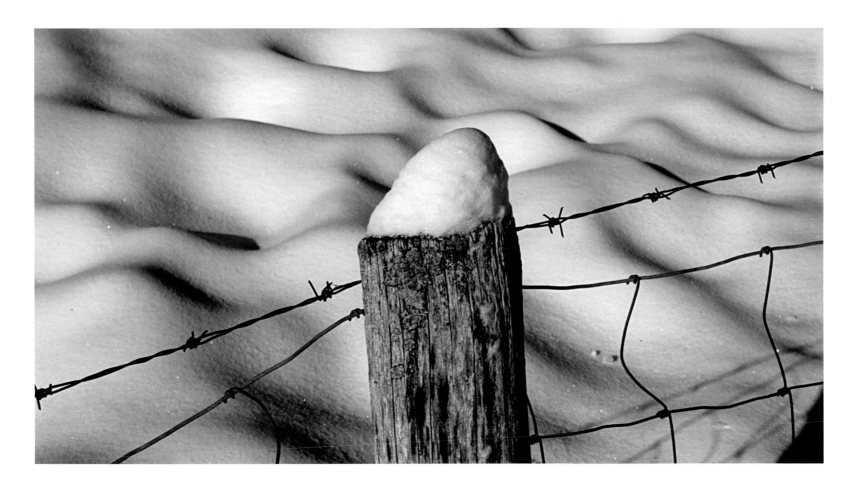

PHOTOGRAPHS BY STEPHEN G. DONALDSON

COMMONWEALTH EDITIONS, BEVERLY, MASSACHUSETTS

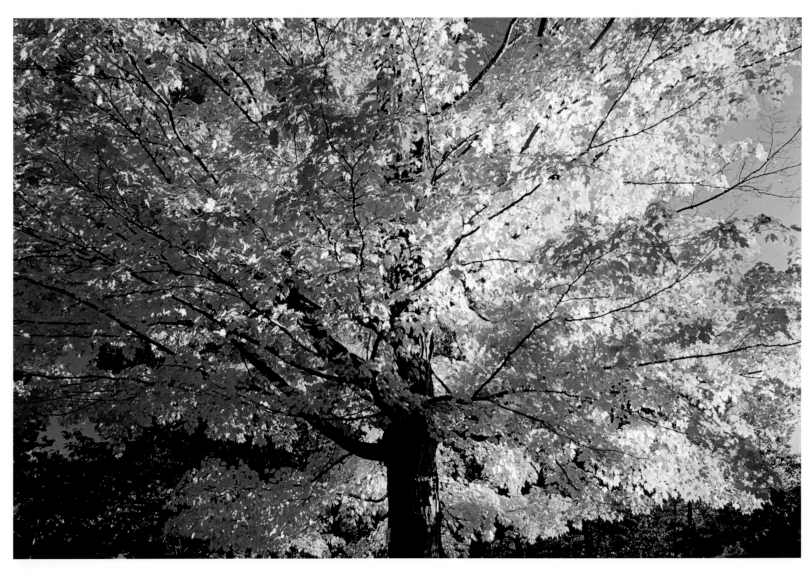

Golden maple on Home Road, Sheffield, at peak foliage

Introduction

By the time this book arrives on store shelves in the summer of 2007 I will be celebrating my ninth year in the Berkshires, and I will have lived here longer than I have lived anywhere else in my lifetime. Prior to arriving here, much of my life was spent in a sort of nomadic pursuit of the ideal place, or at least the closest thing to it that I could find. The funny thing is, I had lived near the Berkshires for a long time and had driven around and through them on many occasions on my way to Vermont from New York City, but I never knew that this ideal place existed. How amazing when you consider the following!

As much as any place in the United States, Berkshire County traces the history, and embodies the spirit, of our country from its very beginnings. Once home to several Mahican tribes of the native Algonquin nation, the Berkshires were first infiltrated by European explorers and traders in the early 1600s. The first recorded clash between Mahicans and Europeans took place in 1675 in what was to become Great Barrington.

By the early 1700s Berkshire County was part of a rapidly developing embryonic nation whose birth would be linked to events that unfolded here. The Sheffield Declaration (1773), which presaged the Declaration of Independence, was drafted here, and the first armed challenge to British rule, commemorated in front of Great Barrington's town hall, took place here in 1774.

Due to the actions of Mum Bett and her great-grandson W.E.B. Dubois, the Berkshires have a legitimate claim to being the birthplace of the civil rights movement. Great Barrington would become the first town in the nation to have its main street illuminated by electric street lamps. Fine Berkshire marble, quarried in Sheffield and Lee, would be used in the construction of such great symbols of the developing nation as the Capitol Building in Washington D.C., Grant's Tomb, the Boston customs house, New York's city hall, and the Empire State Building. Since 1879, Crane & Co., based in Dalton, has been the sole supplier of paper used for our currency. Furthermore, many of the greatest names in American literature, Herman Melville, Edith Wharton, and Nathaniel Hawthorne among them, lived and wrote in the Berkshires. Daniel Chester French designed the Lincoln Memorial here, and Norman Rockwell created some of the most enduring and iconic American art chronicling small-town life in the twentieth century in his paintings and illustrations.

Berkshire County is so steeped in culture and rich in history that it carries the moniker "America's premier cultural resort." Additionally, the Berkshires remain a place of gentle and elegant scenic beauty. With the city of Pittsfield as its geographic hub, Berkshire County extends in all directions in seemingly endless rolling hills laced with dairy farms and delineated by dry-stone walls. Nestled into these hills are historic villages with country restaurants and antique shops that continuously remind me of my youth growing up in the midlands of England. Above it all looms Mt. Greylock, the highest peak in Massachusetts.

This book is designed to take you on a visual journey through the Berkshires from the southern border with Connecticut to the northern border with Vermont. The photography you will see celebrates this treasure of history, culture, and scenic beauty that is Berkshire County today.

—Stephen G. Donaldson
Spring 2007

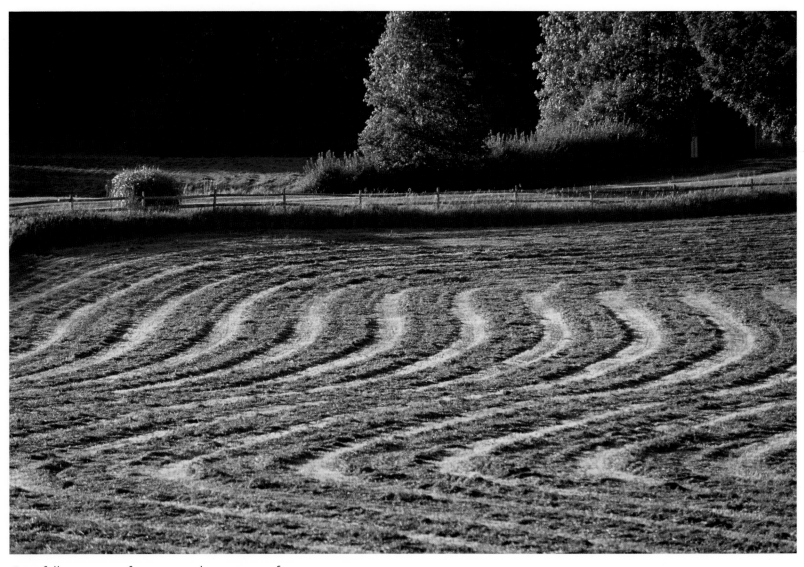

Gracefully cut rows of grass trace the contours of a
field in Ashley Falls.

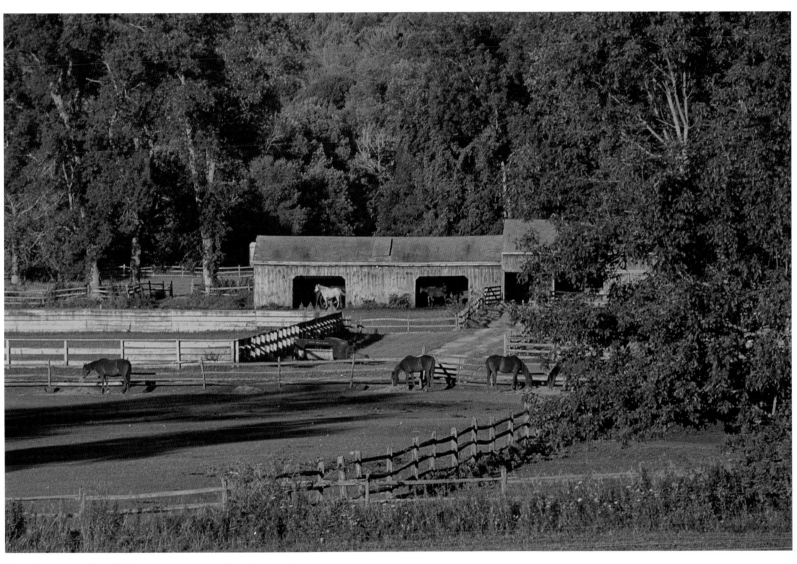

The first rays of sunlight create a tranquil early morning scene on a horse farm in Ashley Falls.

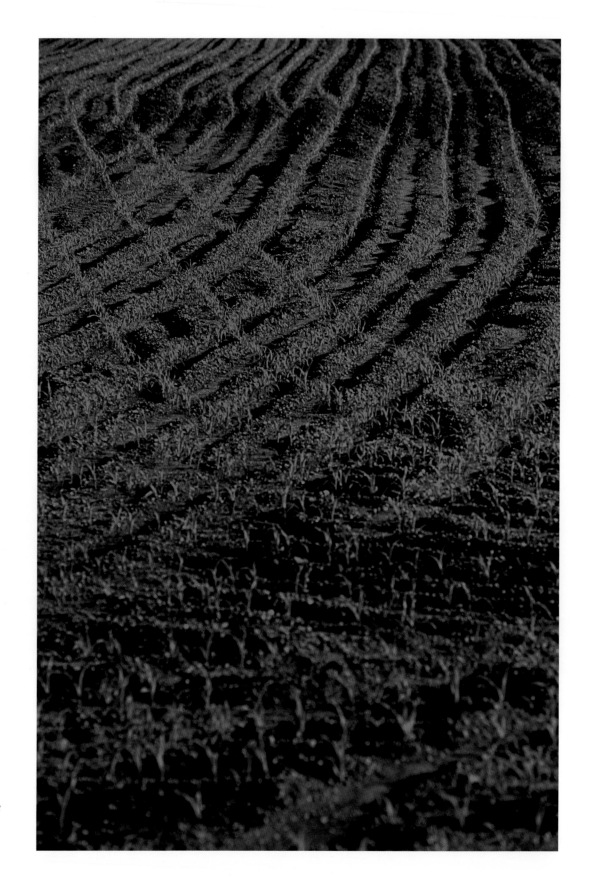

Converging patterns of
sprouts in a cornfield give
it the look of a bustling
rail yard.

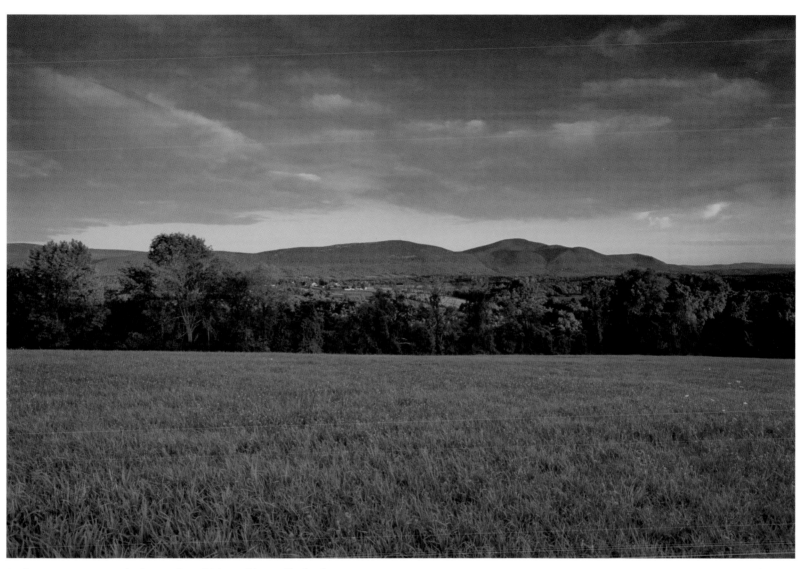

Early morning on Bartholomew's Cobble, Ashley Falls, looking west
toward Mt. Everett

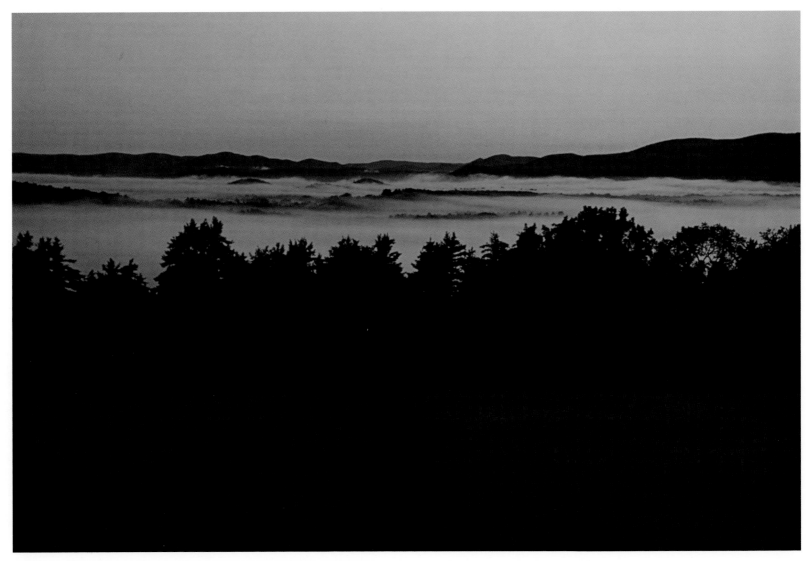

Sunrise over a fog-shrouded Housatonic Valley, looking north from
Bartholomew's Cobble in Ashley Falls

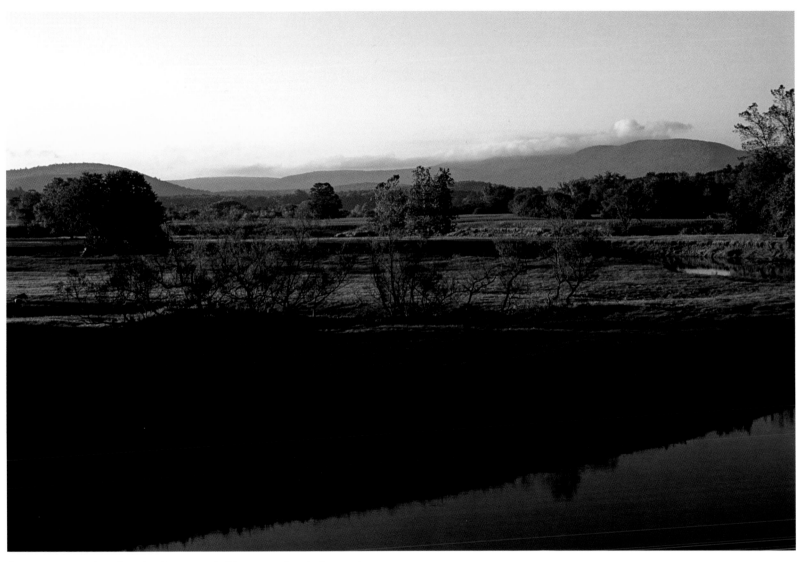

Sunrise view at bend in the Housatonic River near Bartholomew's
Cobble in Ashley Falls

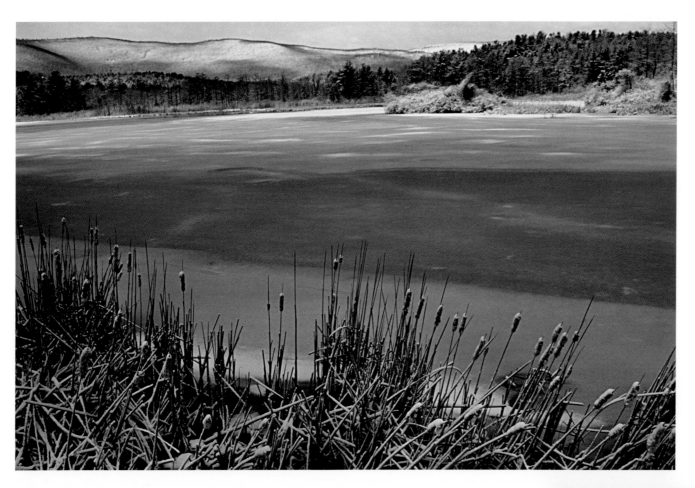

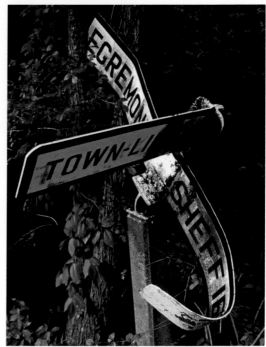

Above: Smiley's Pond, South Egremont

Right: Sheffield-Egremont town line

12

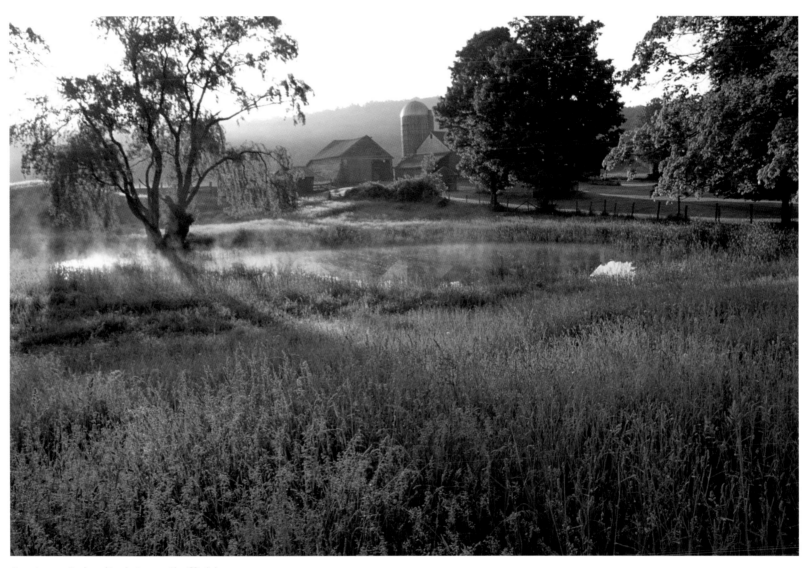

Sunrise at Delmolino's Farm, Sheffield

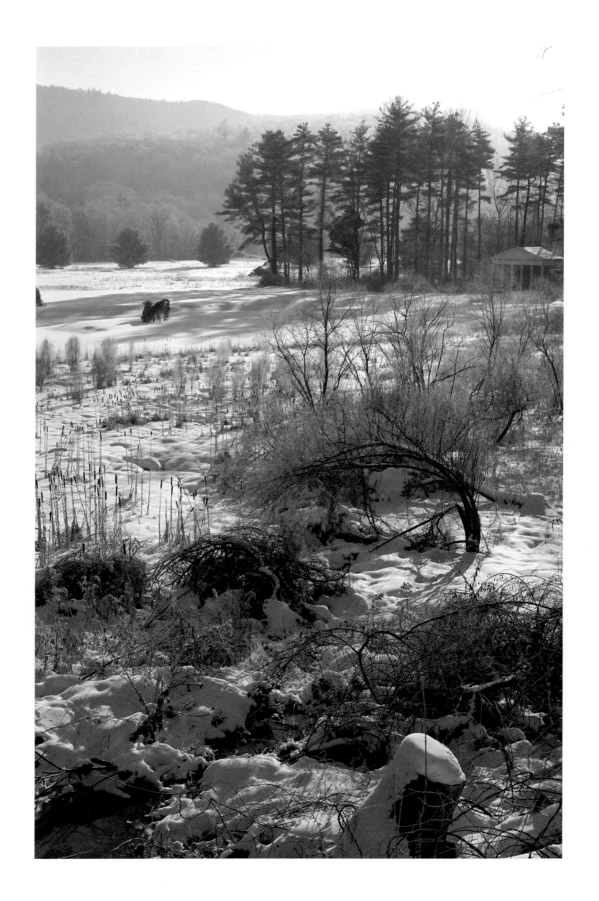

East Mountain from across
the grounds of Searles
Castle, Great Barrington

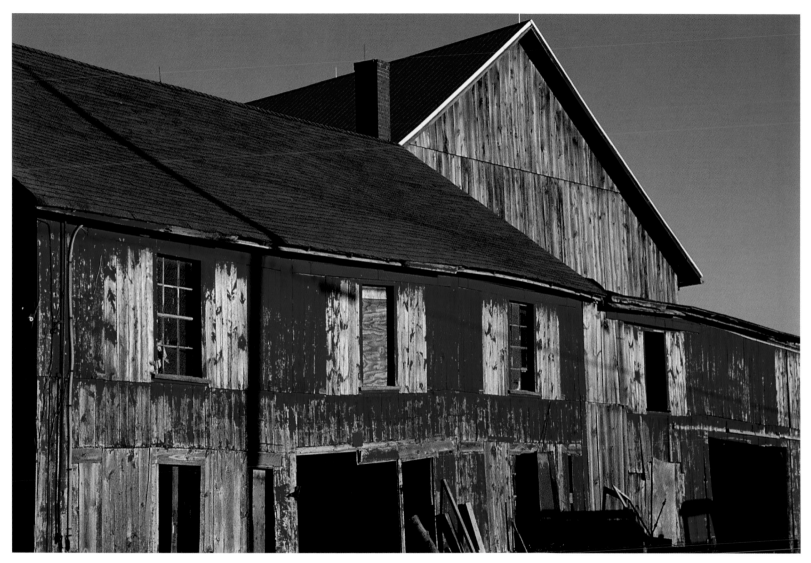

One of a dying breed of historic barns, Baldwin Hill, North Egremont

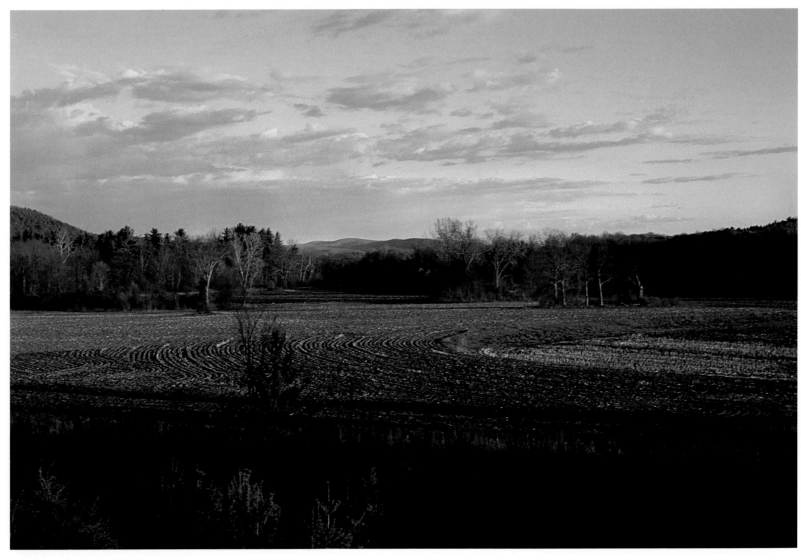

Off Route 23, between South Egremont and Great Barrington

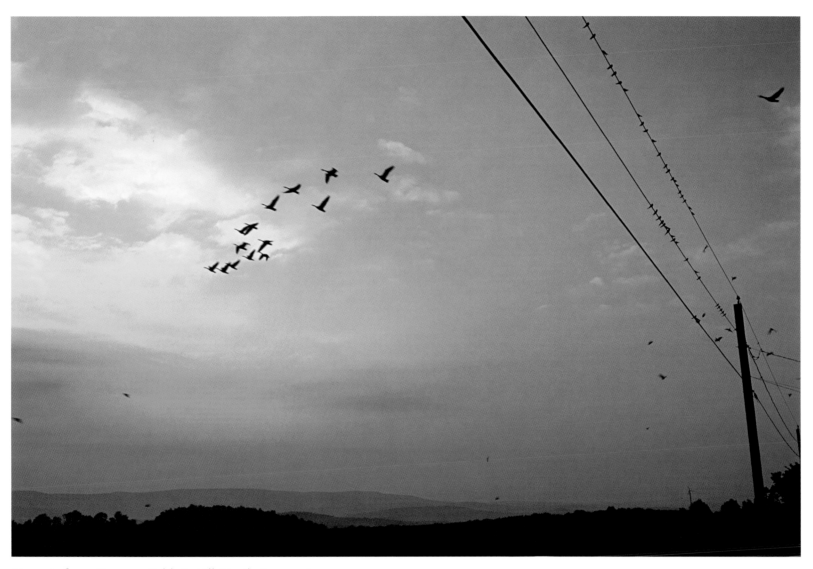

Geese in formation over Baldwin Hill, North Egremont

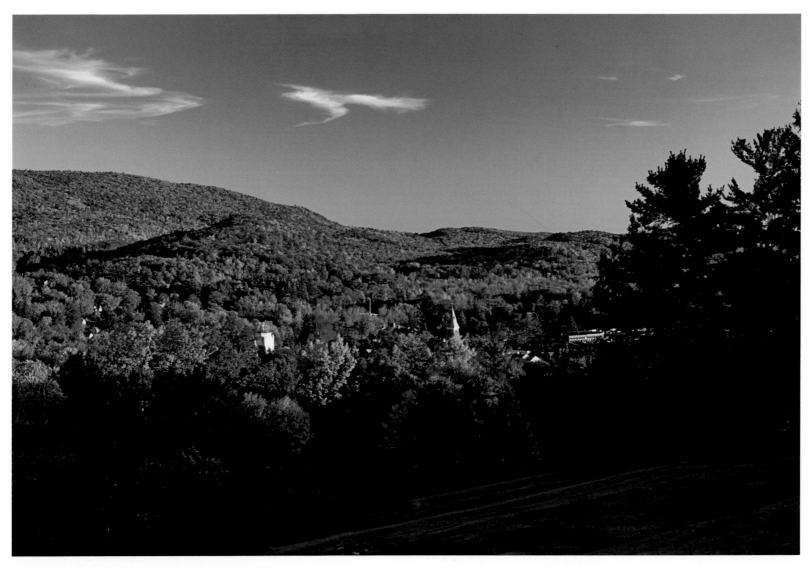

View from the west above Great Barrington

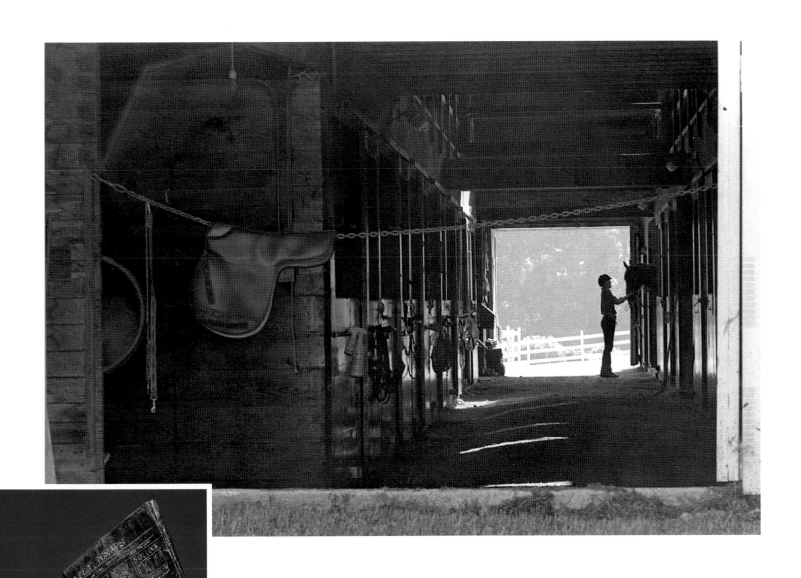

Above: Stables at a horse farm near the Connecticut
line, Sheffield

Left: Newsboy Monument, Route 23, Great Barrington

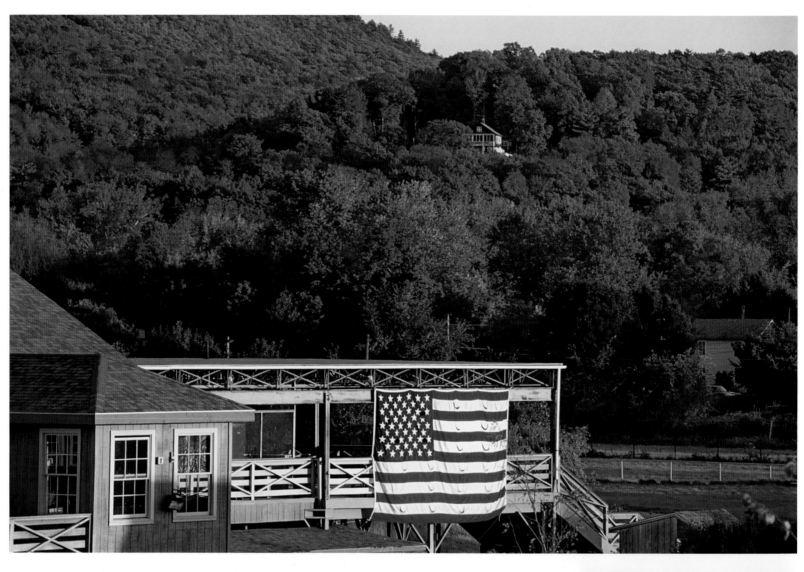

Above: Former fairgrounds on the south side of
Great Barrington

Right: Kids enjoy the spoils of a day of raking on a
residential street in Great Barrington.

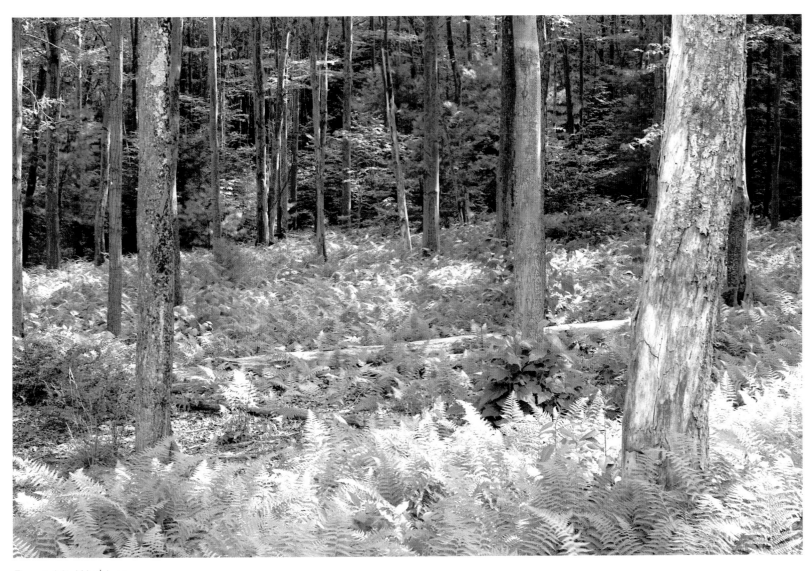

Forest, Mt. Washington

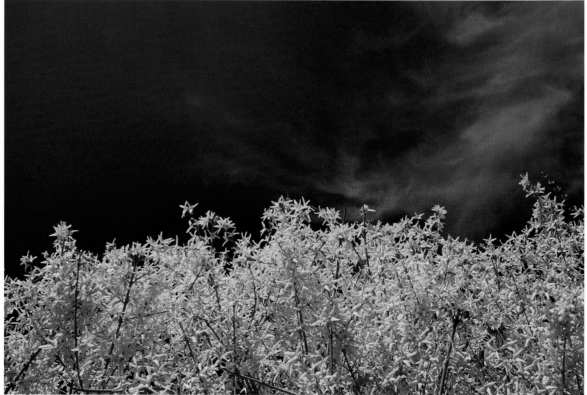

Above: Castle Street, Great
Barrington. Life can indeed be
beautiful in the Berkshires.

Right: Forsythia and sky,
Great Barrington

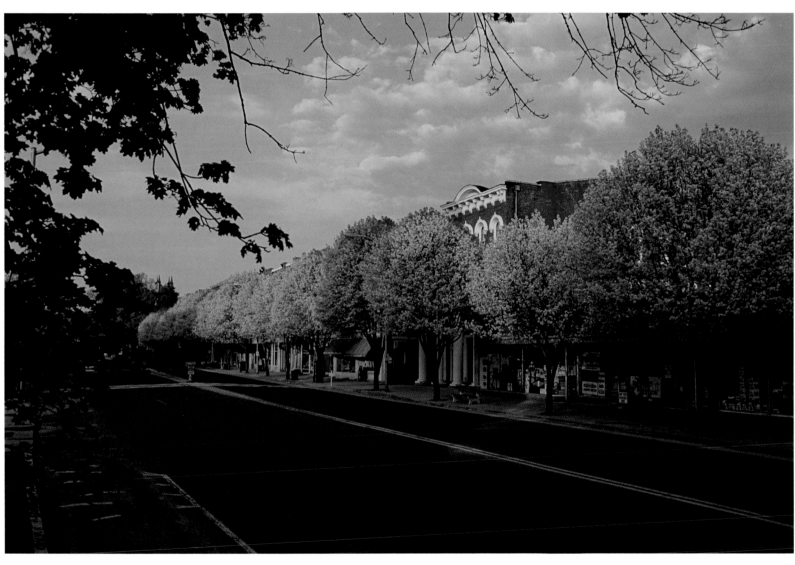

A spring sunrise illuminates pear blossoms, Main Street,
Great Barrington.

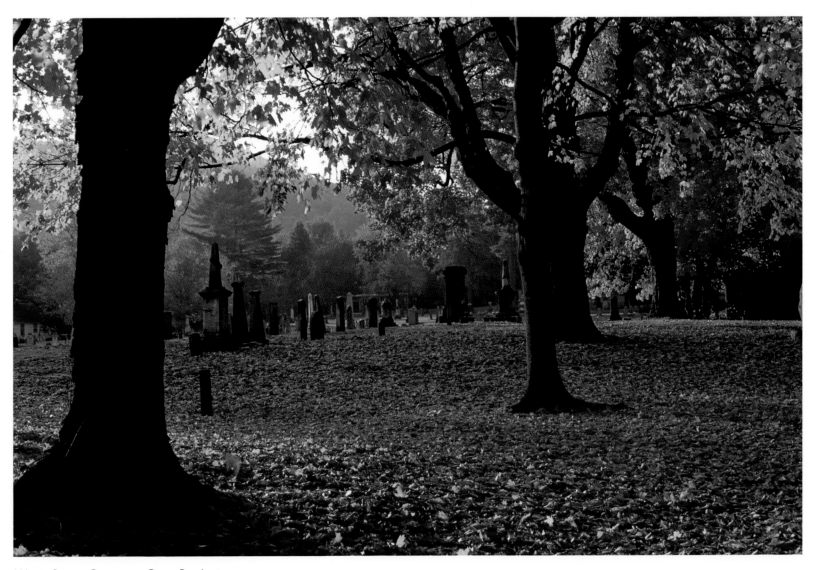

Water Street Cemetery, Great Barrington

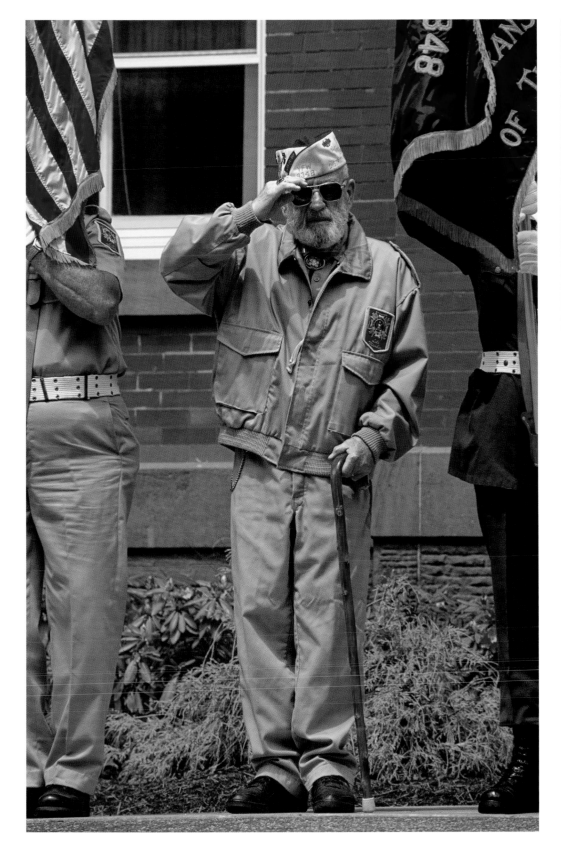

Left and above: Memorial Day,
Great Barrington

25

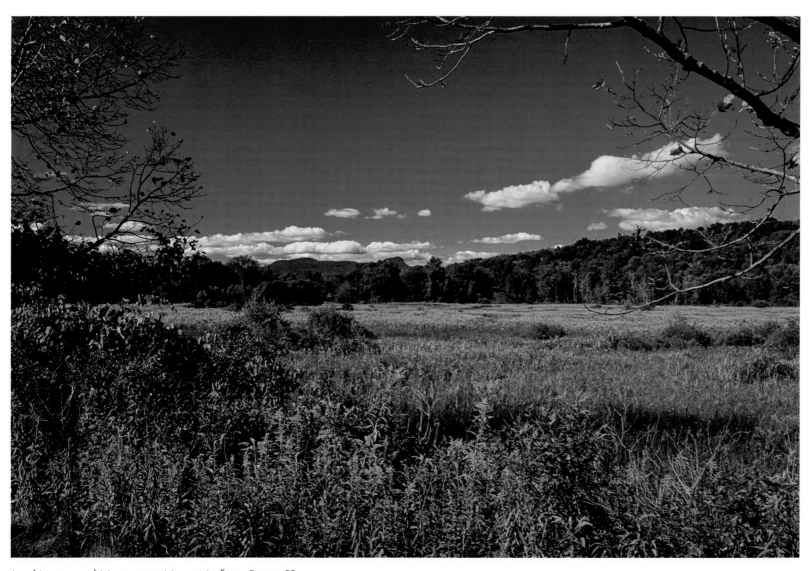

Looking toward Monument Mountain from Route 23,
Great Barrington

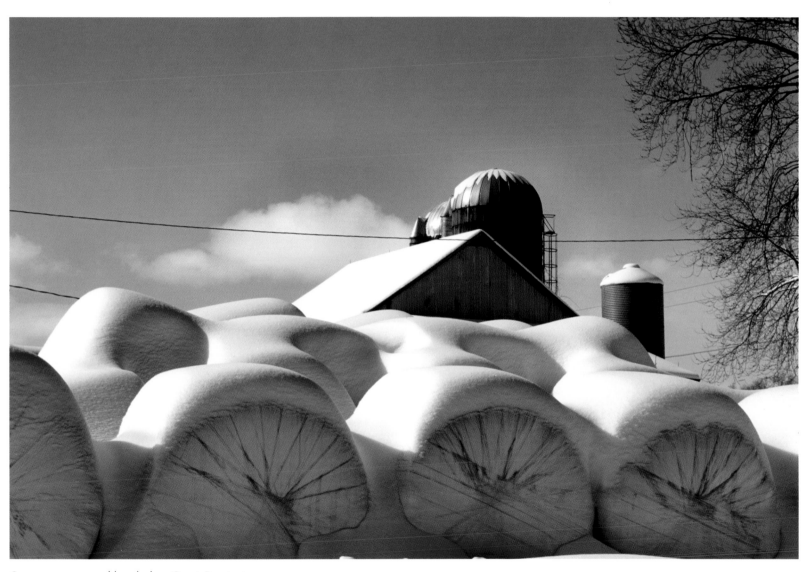

Snow on wrapped hay bales, Great Barrington

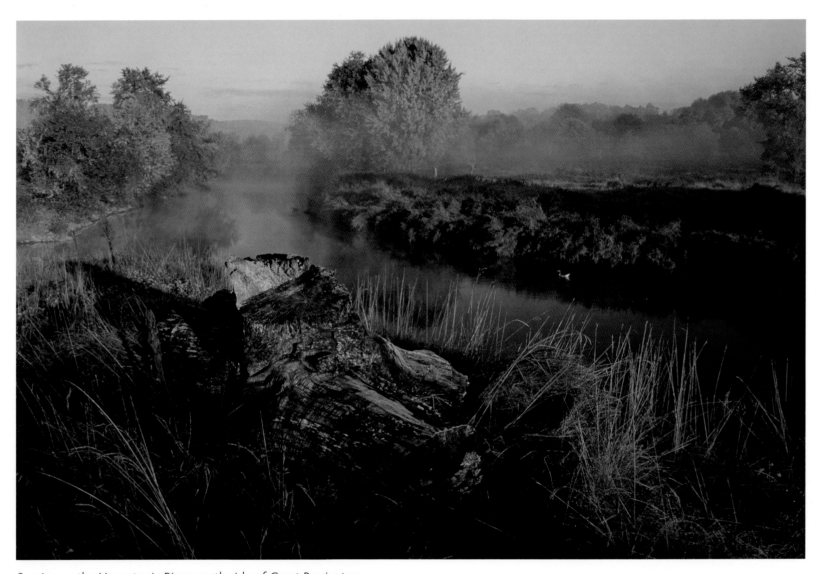

Sunrise on the Housatonic River, north side of Great Barrington

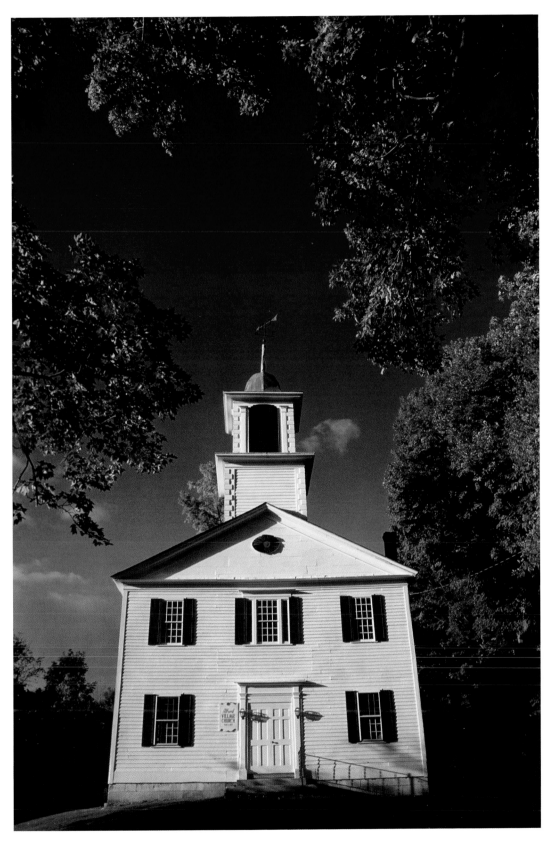

Village Church, Alford

Above: Division Street, between
Great Barrington and Housatonic

Right: Railyard, Housatonic

30

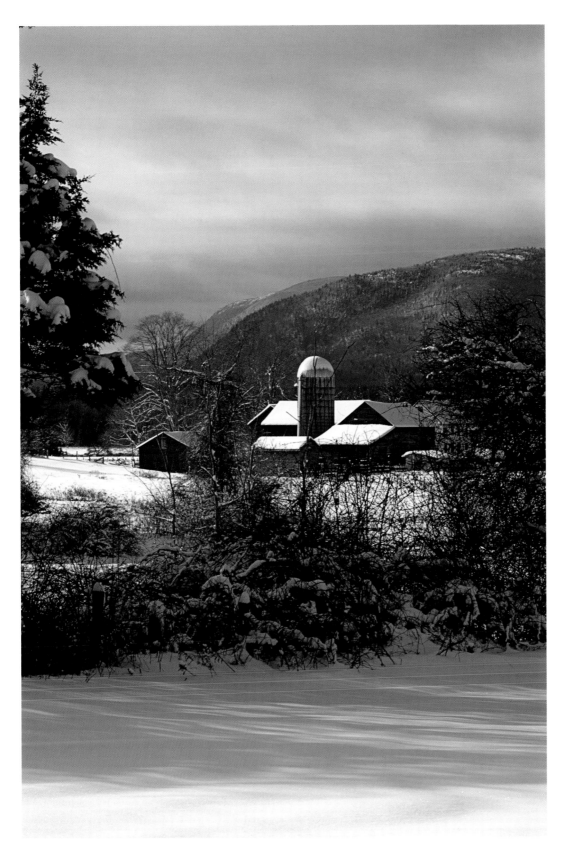

Sunrise at Delmolino's Farm,
Sheffield

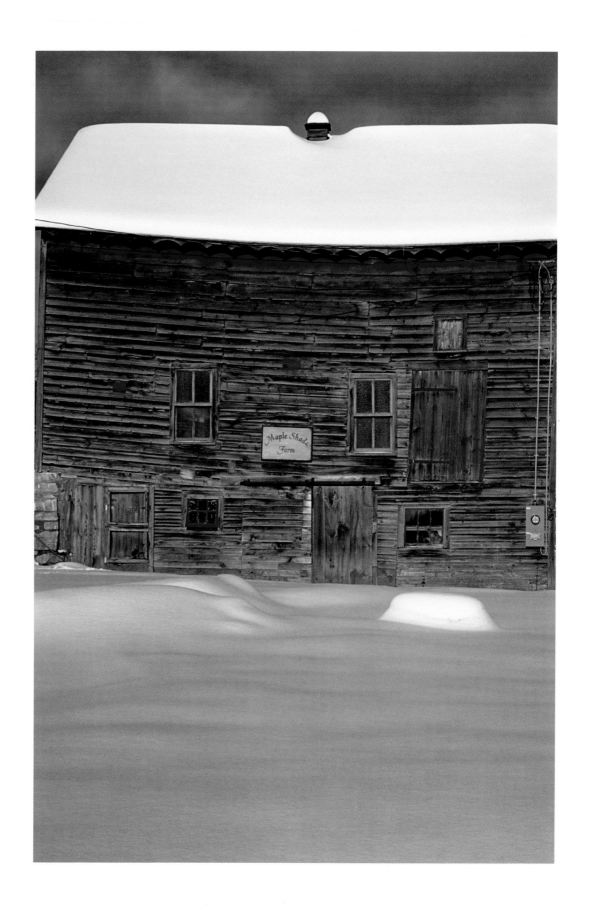

Delmolino's Farm, Sheffield

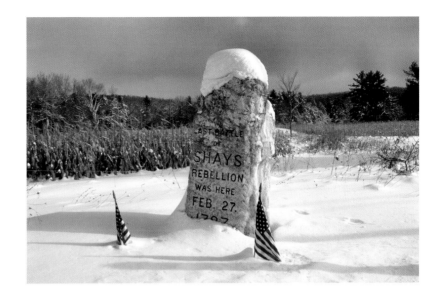

Above: Marker on Sheffield-Egremont Road commemorating Shay's Rebellion, a revolt of farmers against taxes after the American Revolution

Below: Brook west of Delmolino's Farm

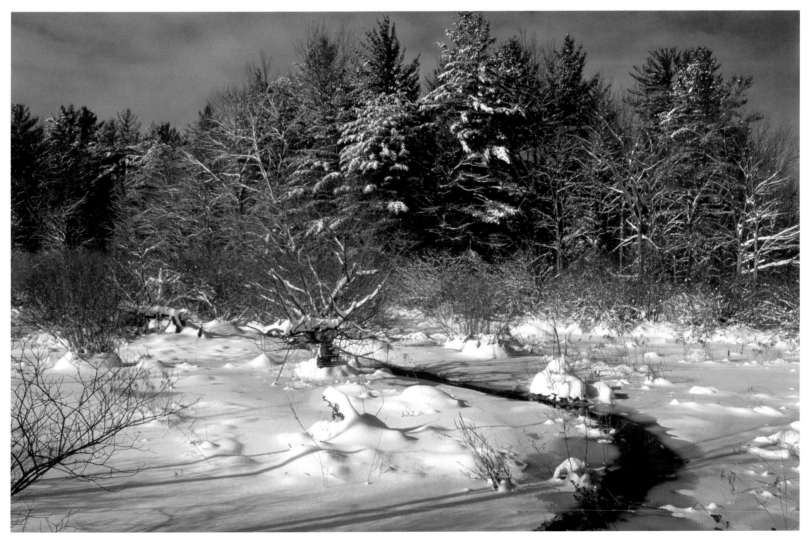

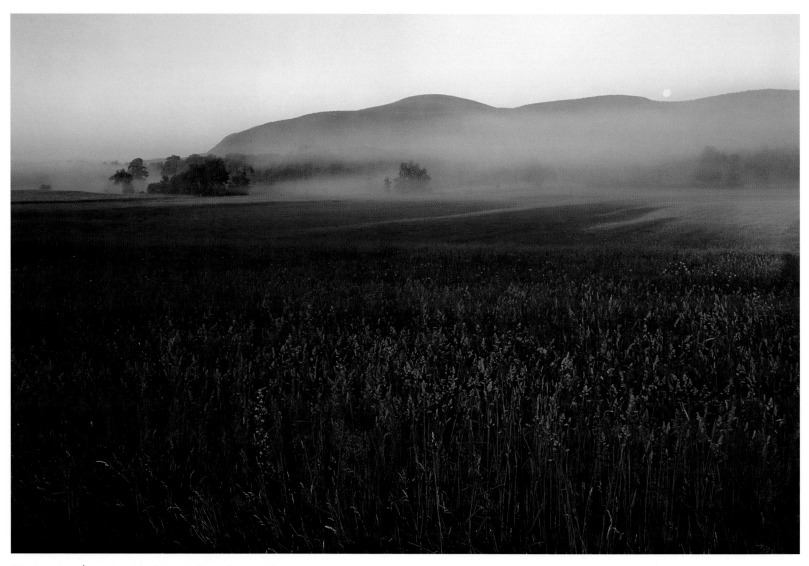

Moonset and sunrise, Mt. Everett State Reservation,
west of Sheffield

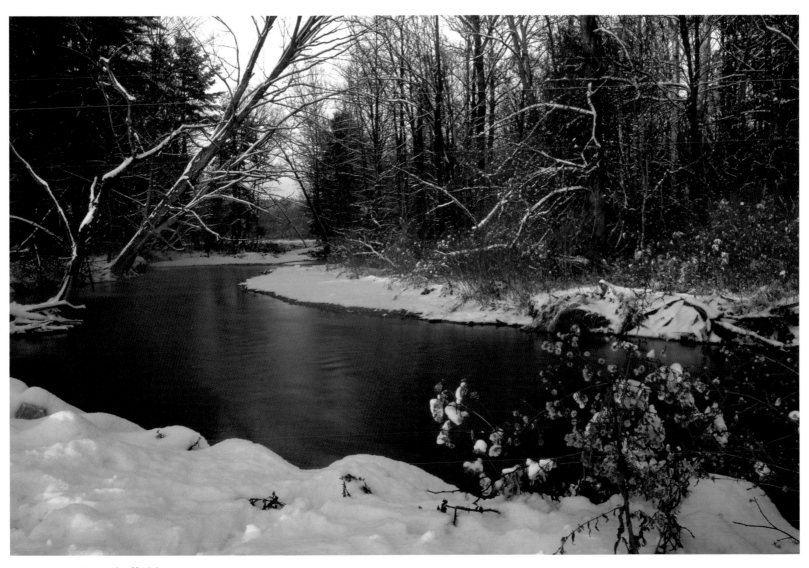

Housatonic River, Sheffield

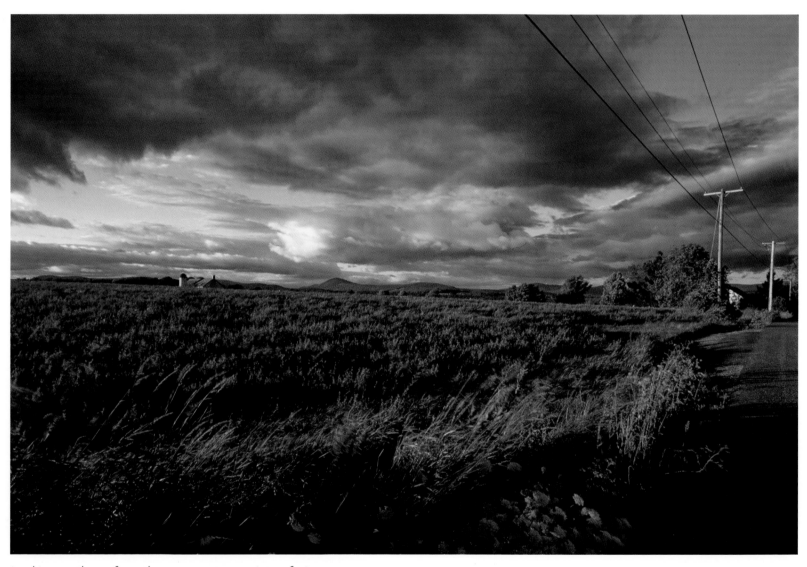

Looking northeast from the same vantage point as facing page

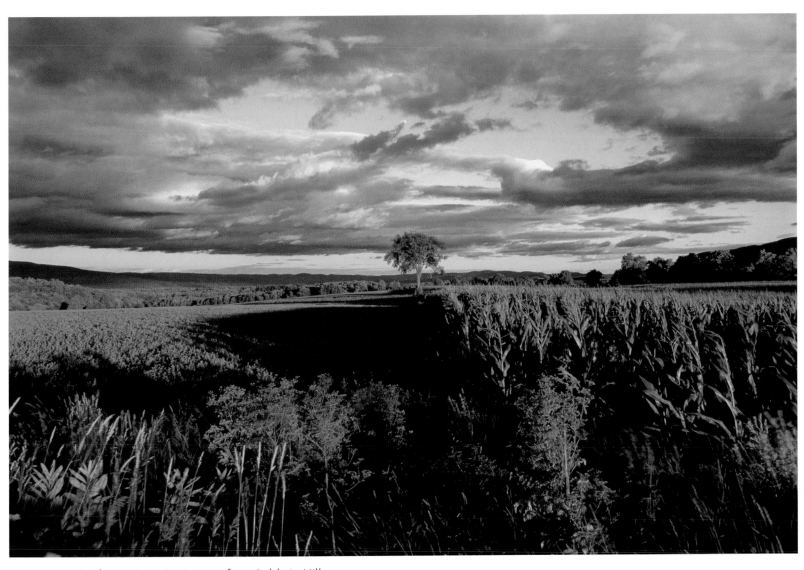

East Mountain above Great Barrington, from Baldwin Hill

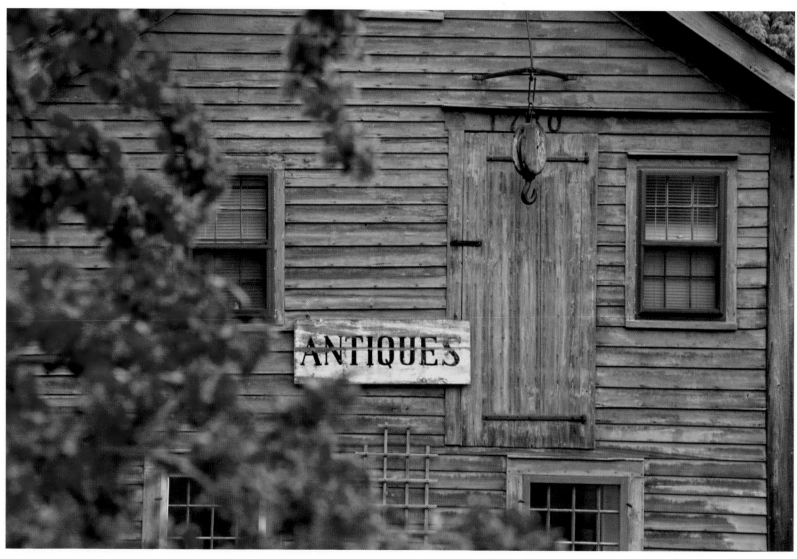

The former Splendid Peasant antique shop, South Egremont

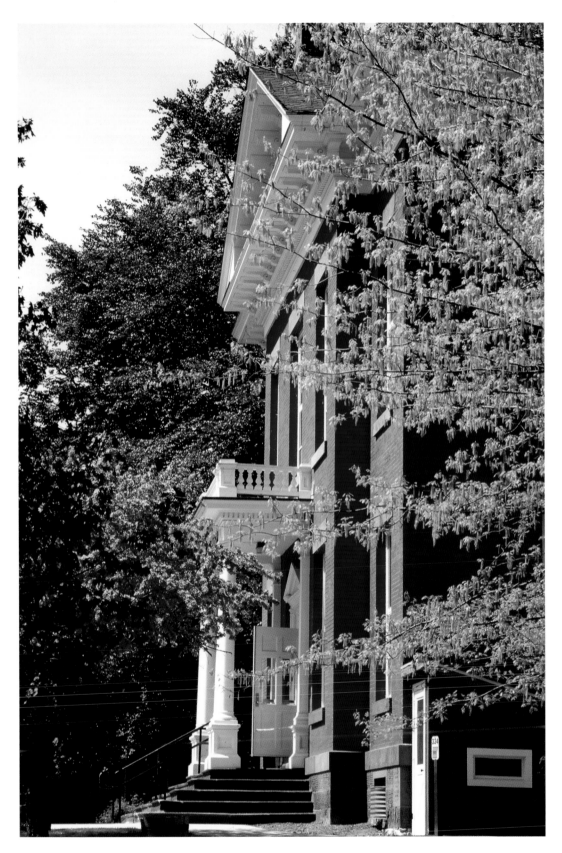

Town hall, Great Barrington, marking the site of the first recorded armed resistance to British rule in 1774

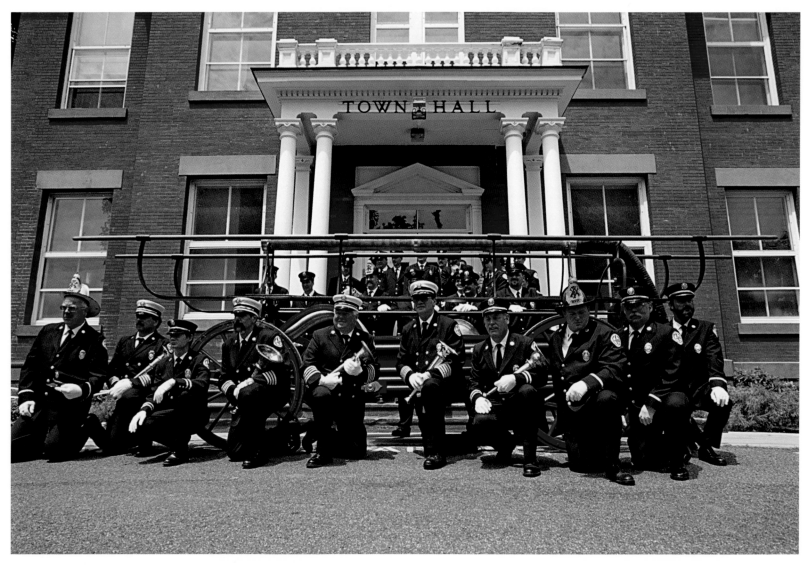

In June 2004 the Hope Fire Company of Great Barrington celebrated its sesquicentennial and paraded an antique fire truck on Memorial Day.

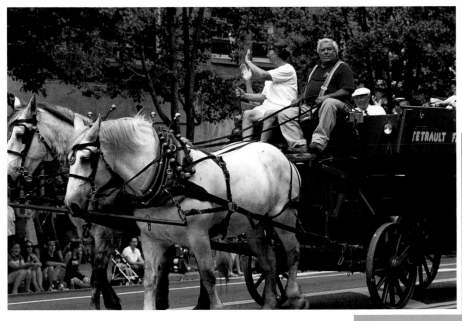

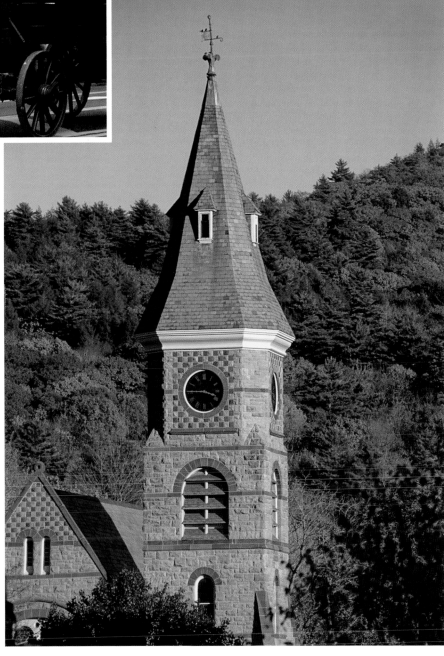

Above: Memorial Day parade, 2004, Great Barrington

Right: First Congregational Church tower, Main Street, Great Barrington

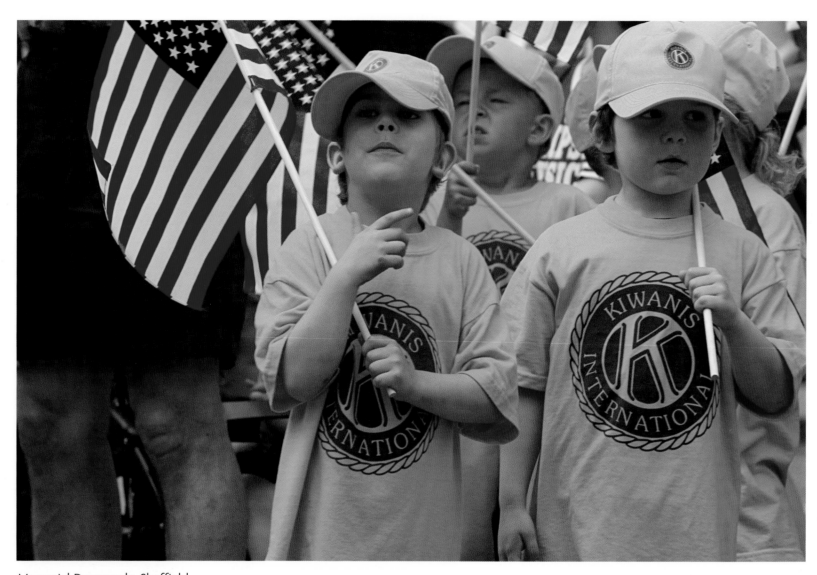

Memorial Day parade, Sheffield

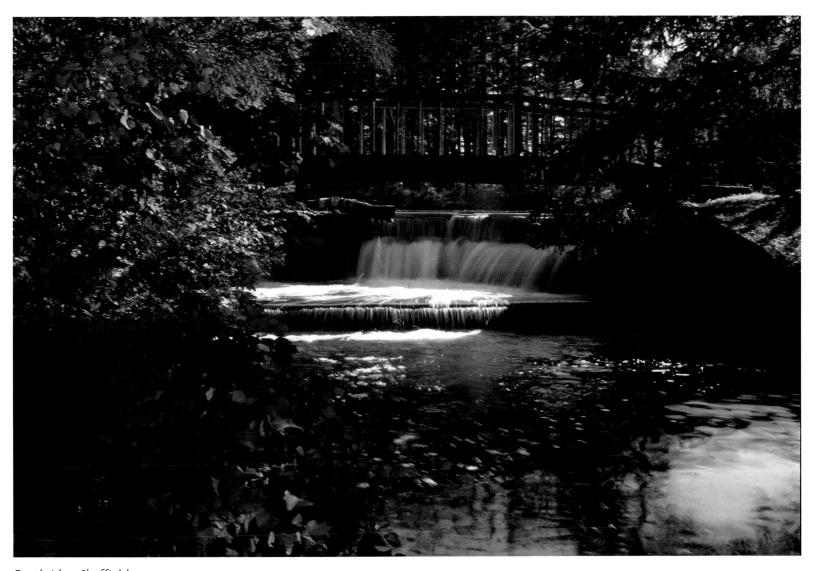

Footbridge, Sheffield

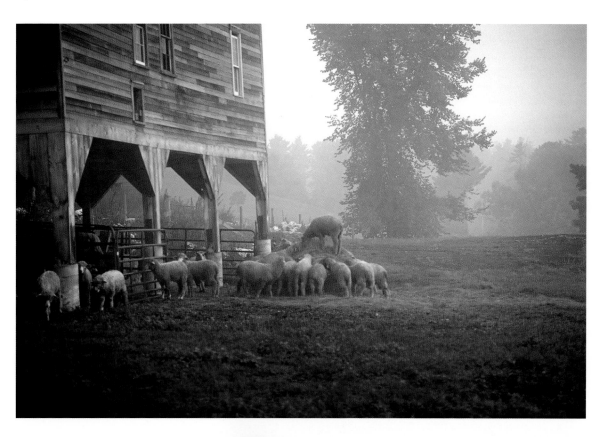

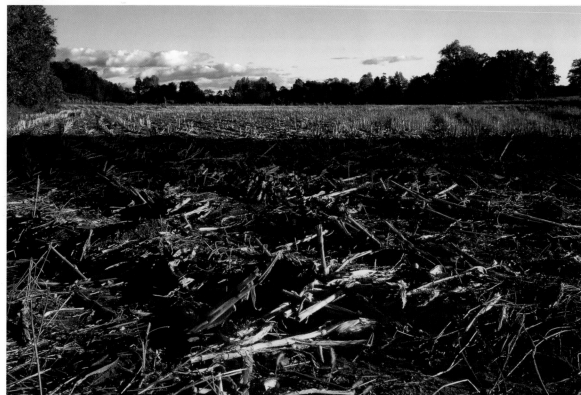

Above: Sheep feast on a mound of hay at the farm on Round Hill, between Great Barrington and North Egremont.

Below: Harvested fields of corn await the arrival of winter in Sheffield.

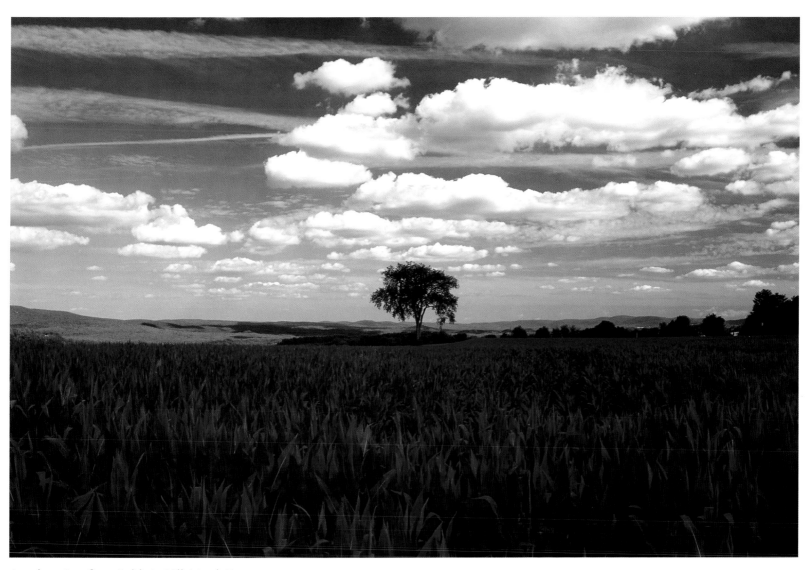

Another view from Baldwin Hill, North Egremont

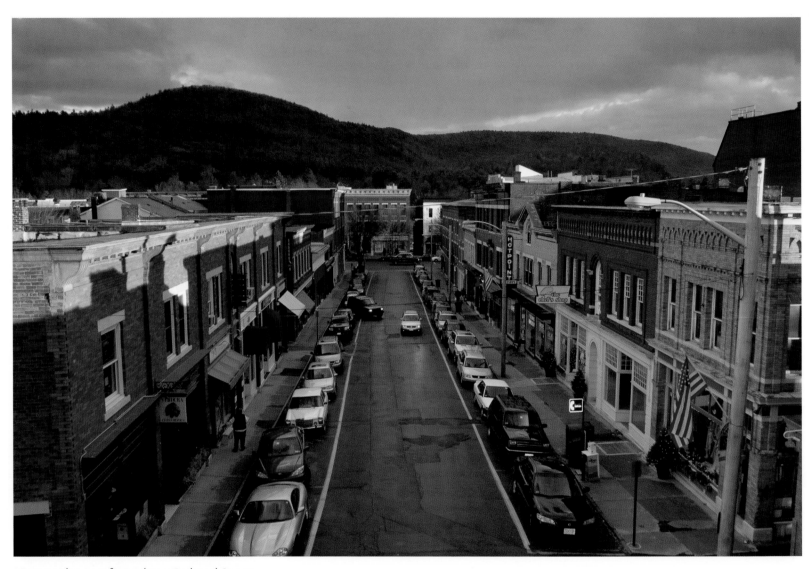

View to the east from above Railroad Street,
downtown Great Barrington

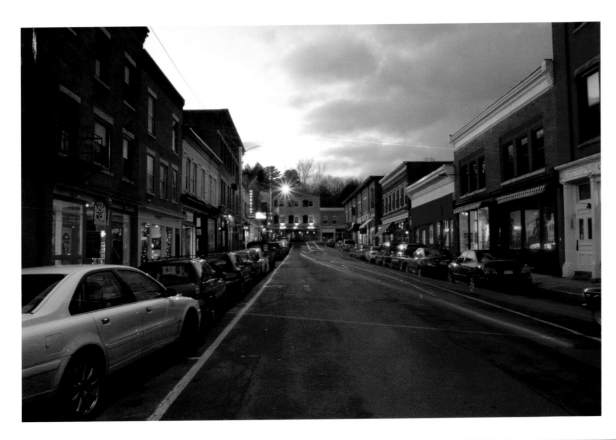

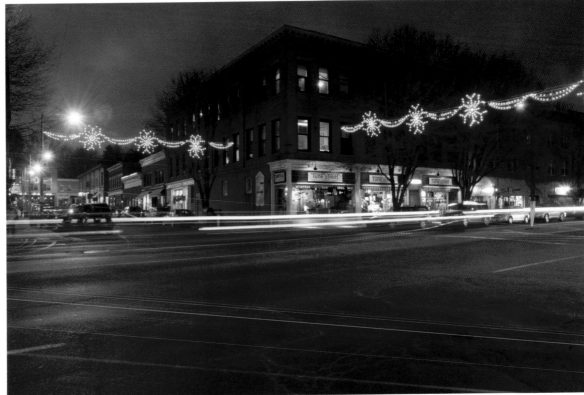

Above: Dusk on a busy evening along Railroad Street, Great Barrington

Right: View up Railroad Street from across Main Street (Route 7), in downtown Great Barrington

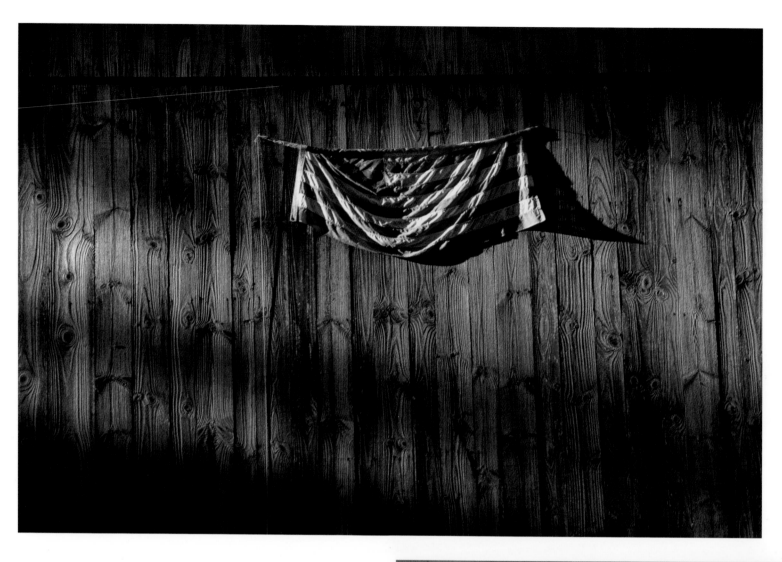

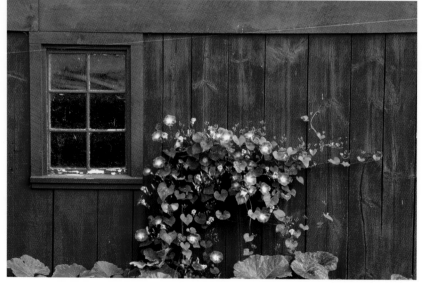

Above: American pride

Below: Morning glories climb a barn wall on Division Street between Great Barrington and Housatonic.

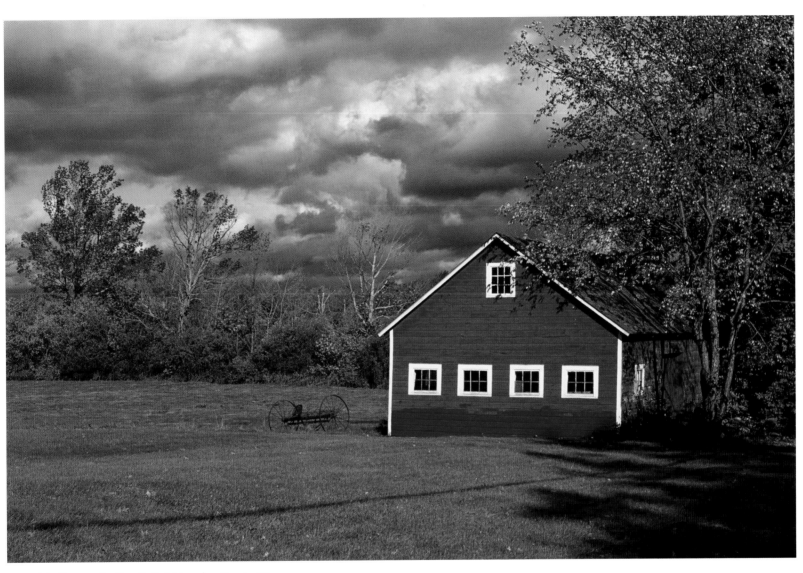

New Marlborough–Sandisfield border, Route 57

Historic barn, New Marlborough

Façade of meeting house, New Marlborough

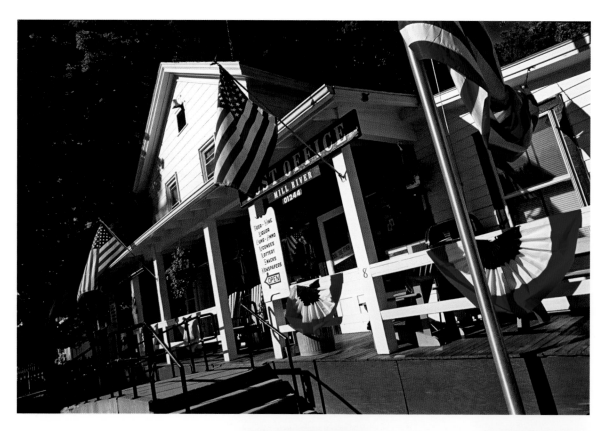

Above: Mill River General
Store, an icon of this corner
of Berkshire County

Below: Memorial Day
parade, Mill River

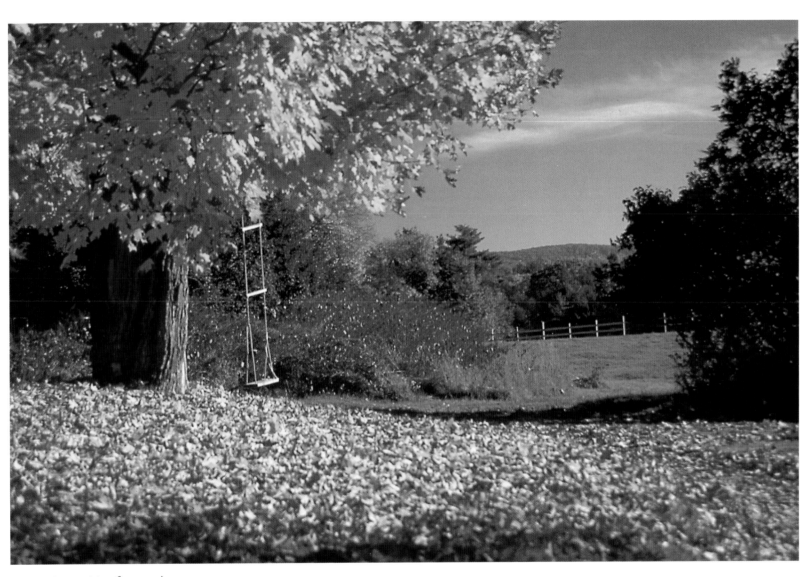

Tree swing waiting for another summer

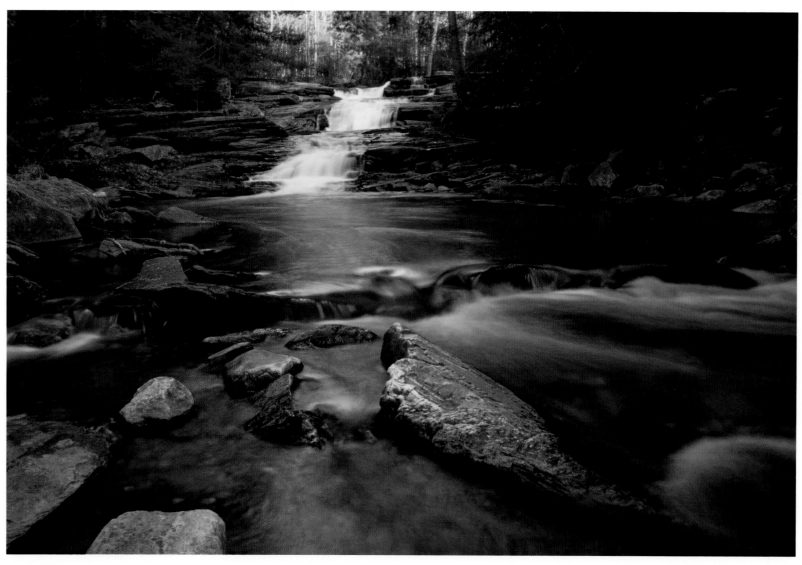

Umpachene Falls, at the confluence of the Umpachene and
Konkapot Rivers, New Marlborough

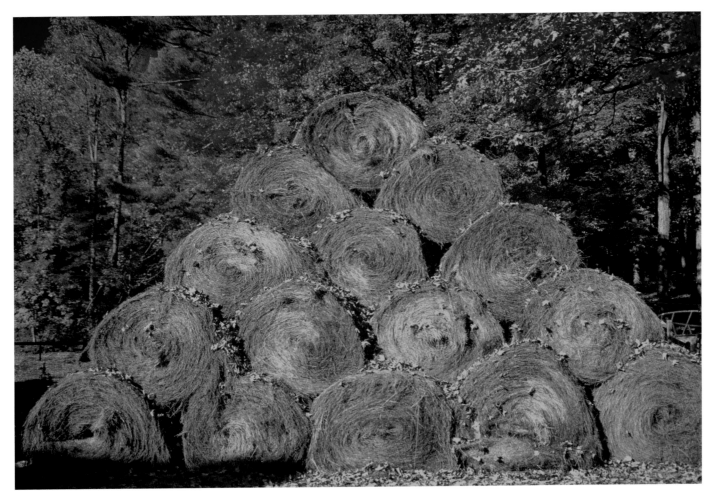

Above: October harvest, Ormsbee's Farm, Mill River

Below: Weathered road sign, Mill River

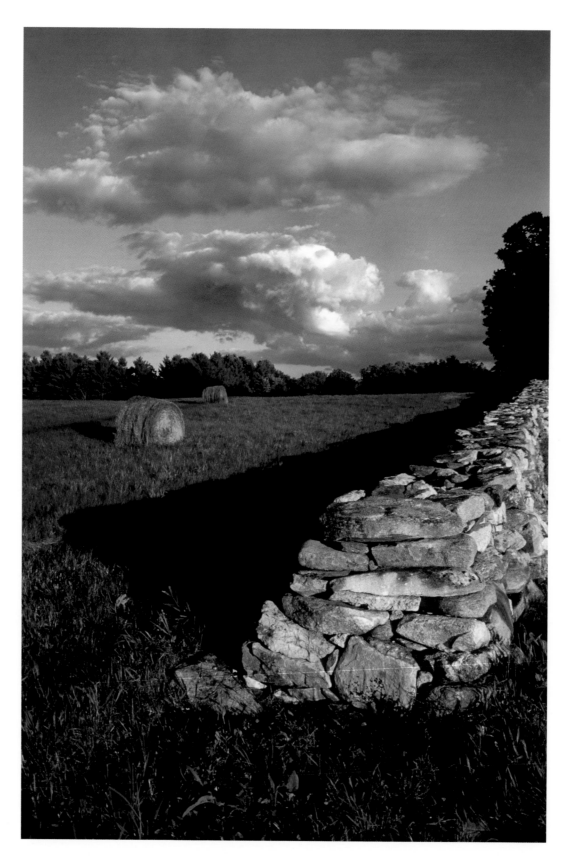

A stone wall evoking memories
of the Midlands

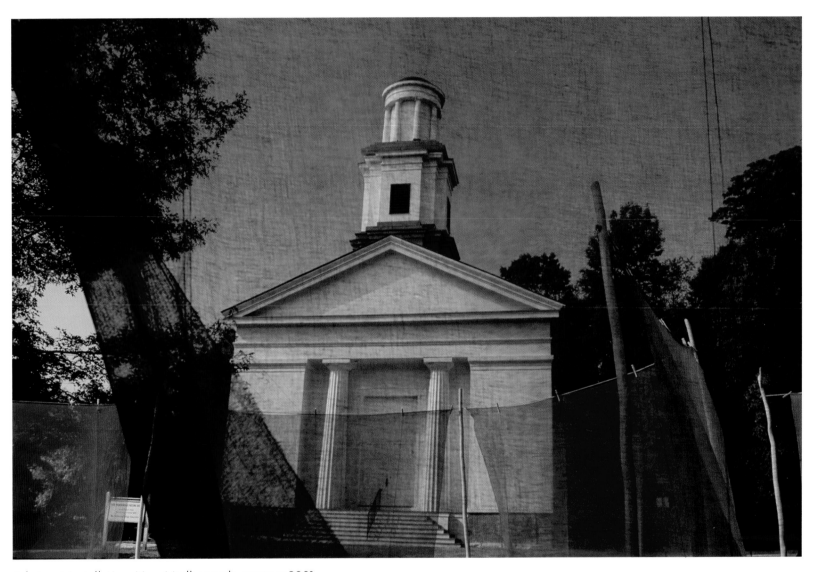

Fabric art installation, New Marlborough, summer 2001

Historic cemetery,
Branch Road, New
Marlborough

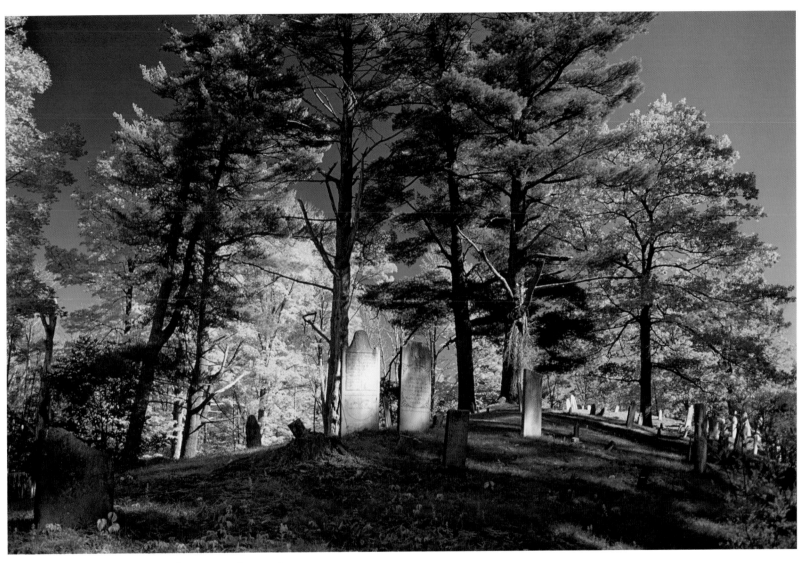

Historic cemetery, Branch Road, New Marlborough

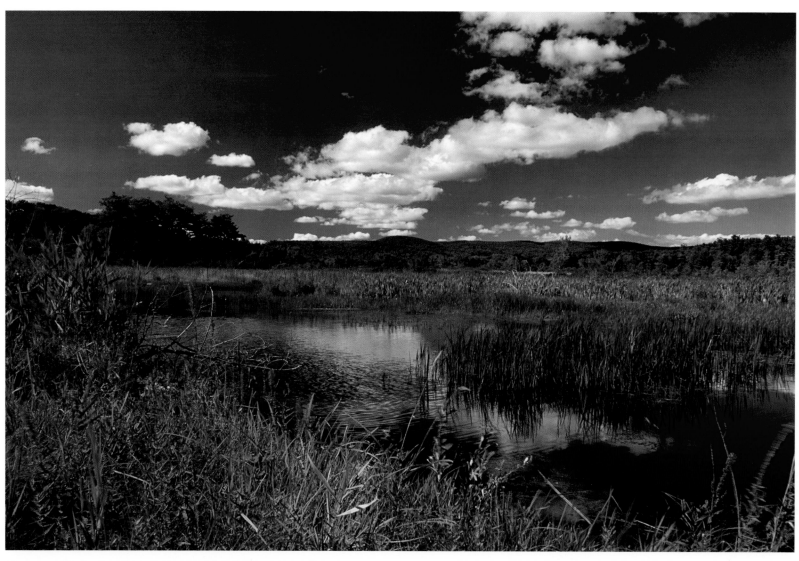

Livermore Peak, seen here from marshlands near Hartsville, rises
above Benedict Pond in Beartown State Forest.

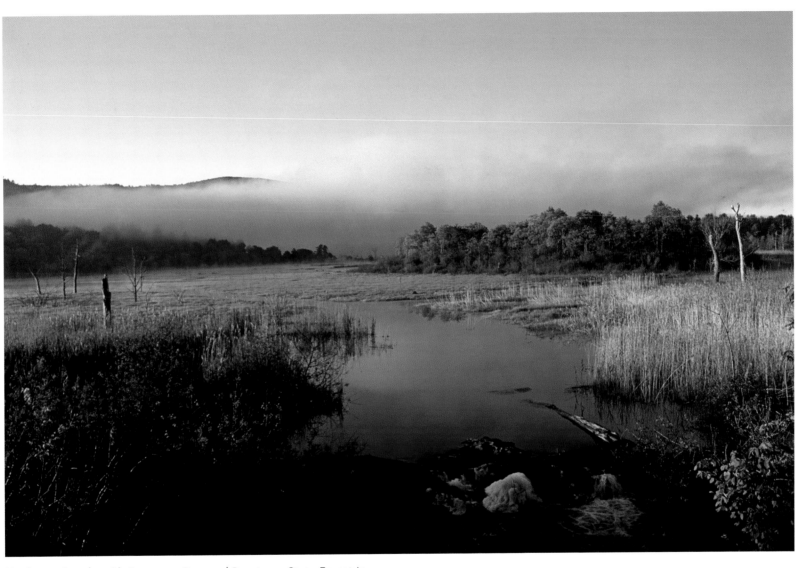

Konkapot Brook, with Burgoyne Pass and Beartown State Forest in
the background

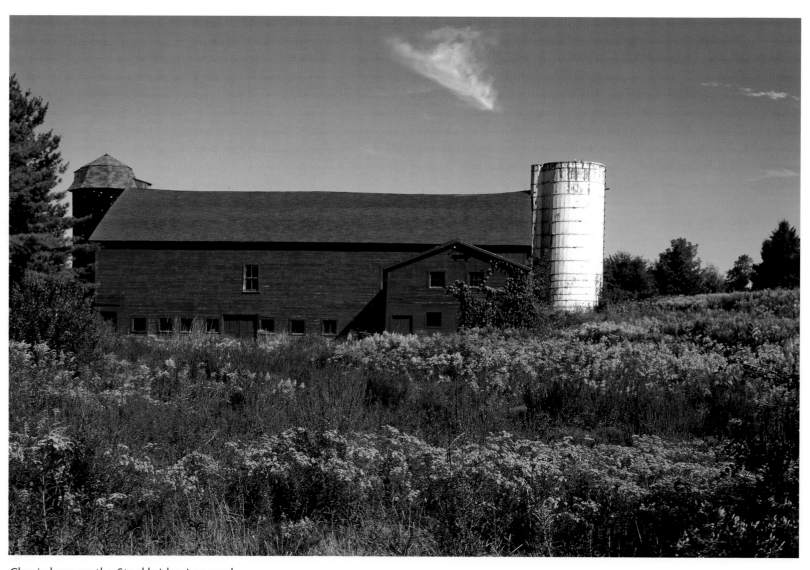

Classic barn on the Stockbridge-Lee road

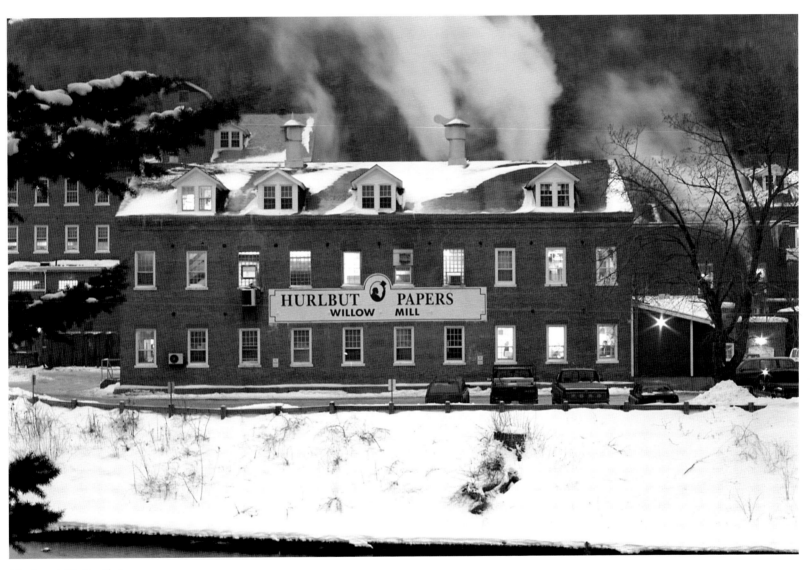

Hurlbut Mill, South Lee

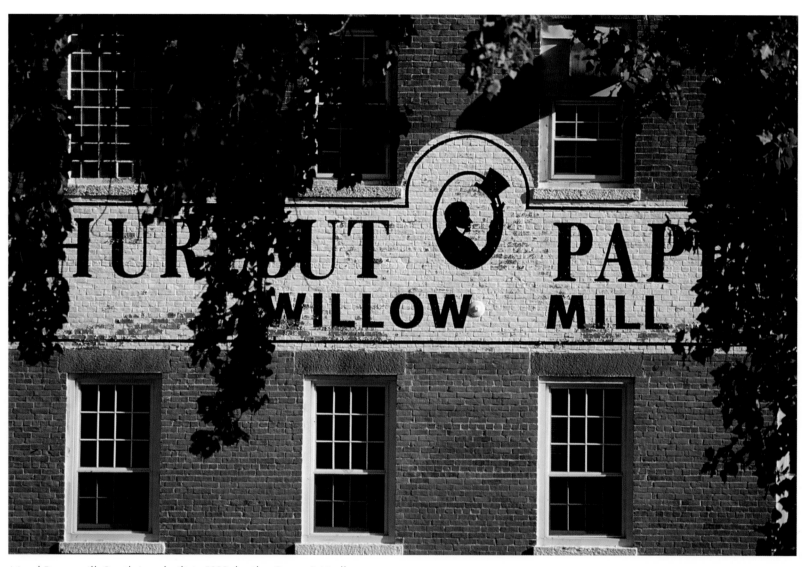

Mead Paper mill, South Lee, built in 1822, by the Owen & Hurlbut
Paper Company

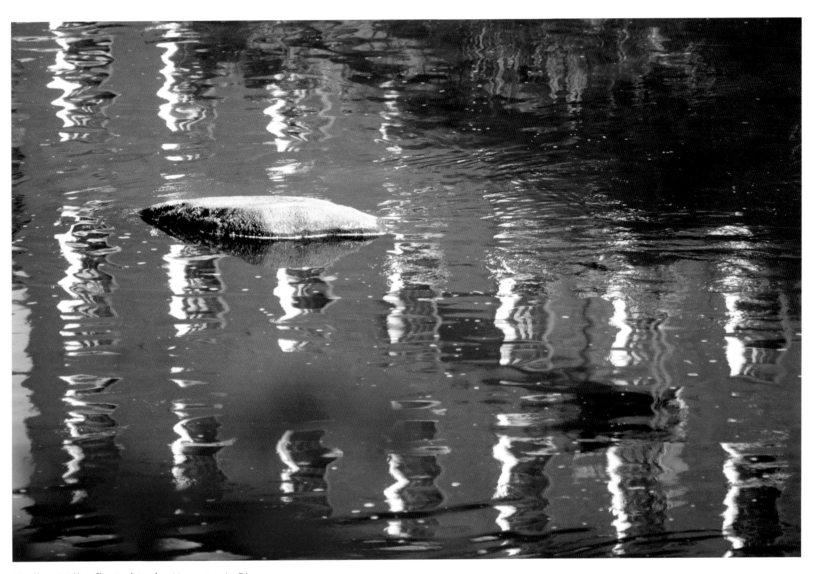

Hurlbut Mill reflected in the Housatonic River

Weathered barn, Hartsville

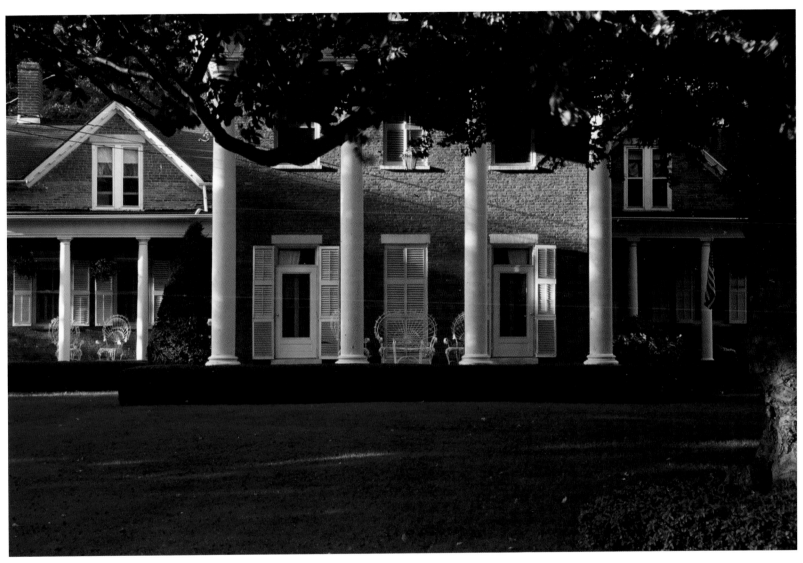

The Federal House, a South Lee landmark, was built in 1824 by
Thomas Hurlbut. It remained in the family until 1960 and has since
become a popular bed & breakfast.

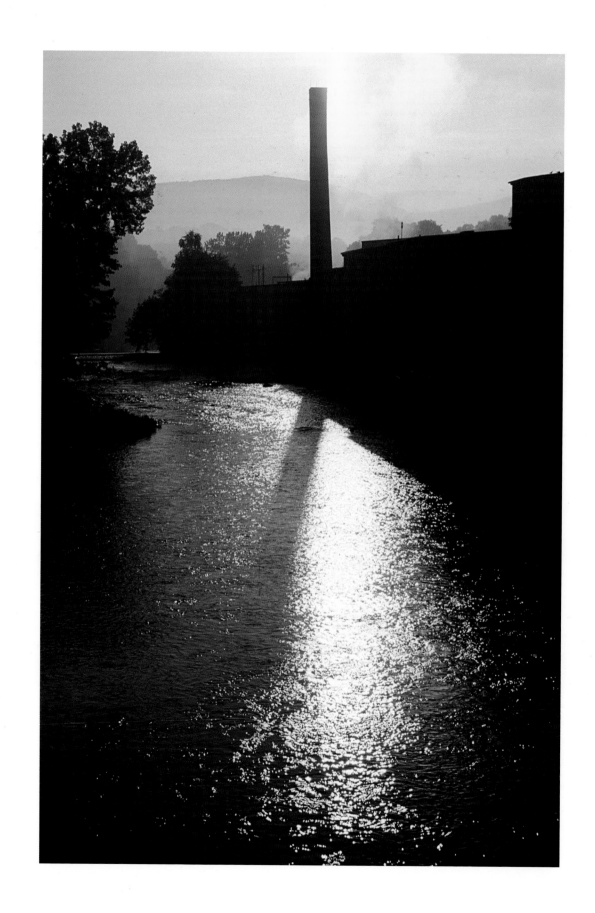

The Schweitzer Mill on the
Housatonic River in Lee

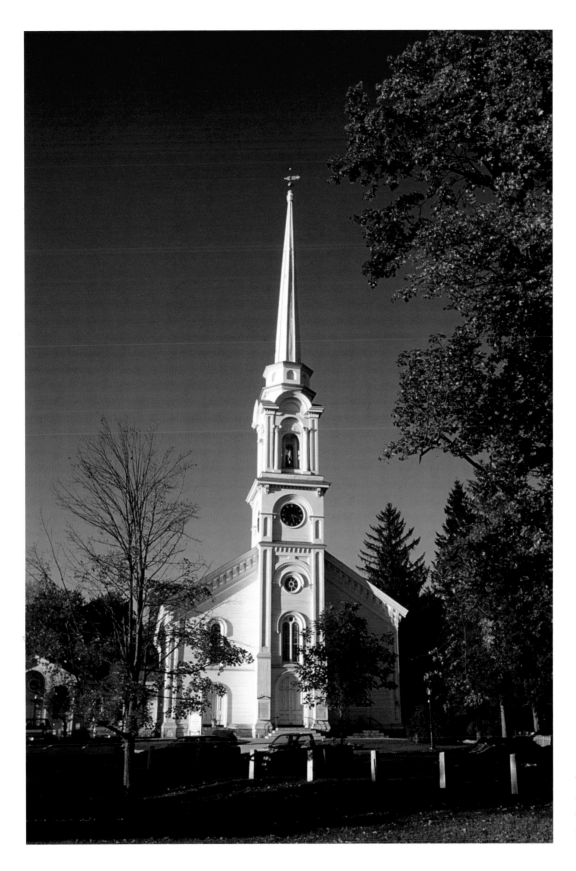

The First Congregational
Church in Lee claims the
tallest wooden spire in
New England, 185 feet high.

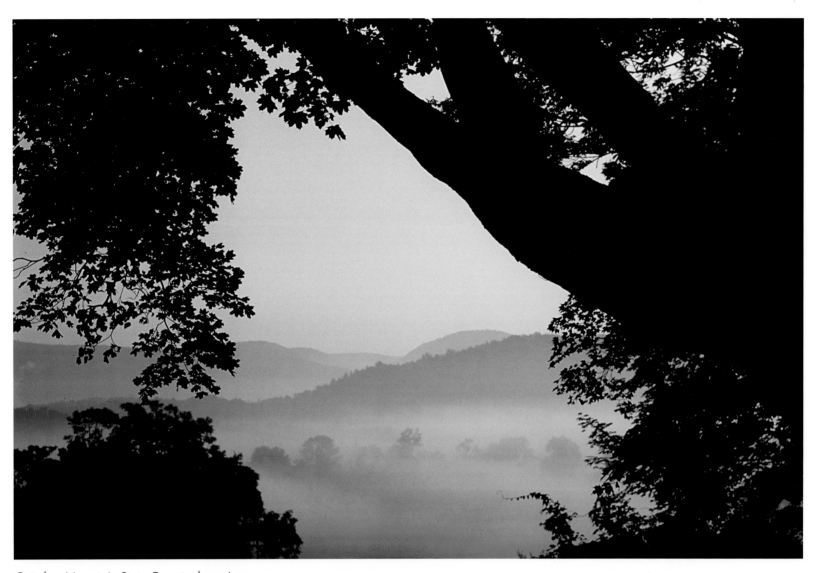

October Mountain State Forest, above Lee

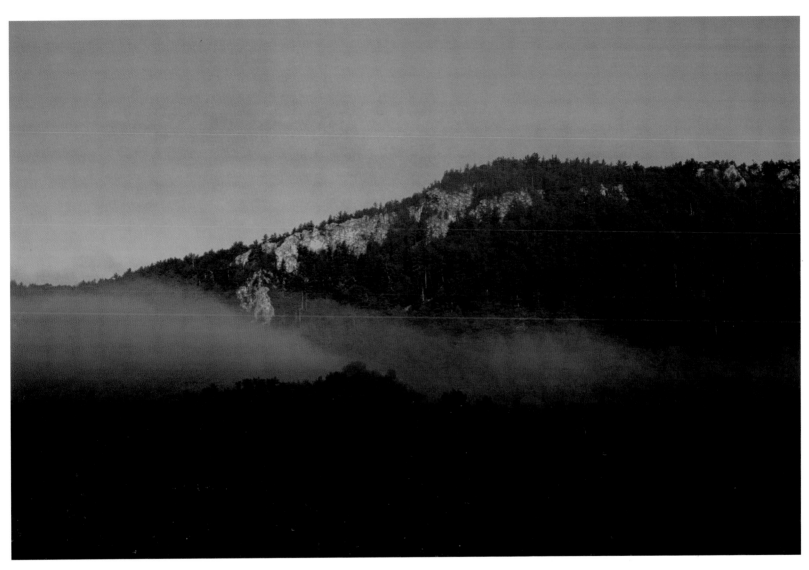

Monument Mountain

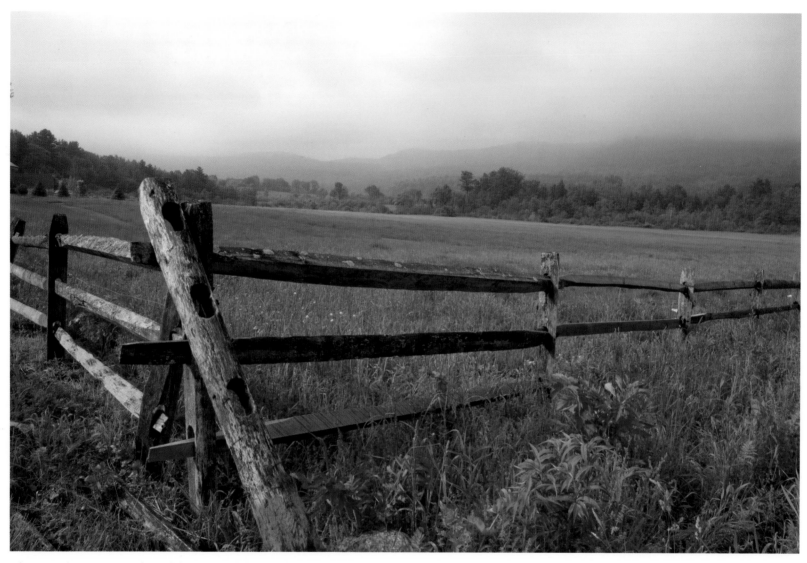

Above and opposite: Split-rail fence, Tyringham—capturing the
enduring pastoral beauty of the Berkshires

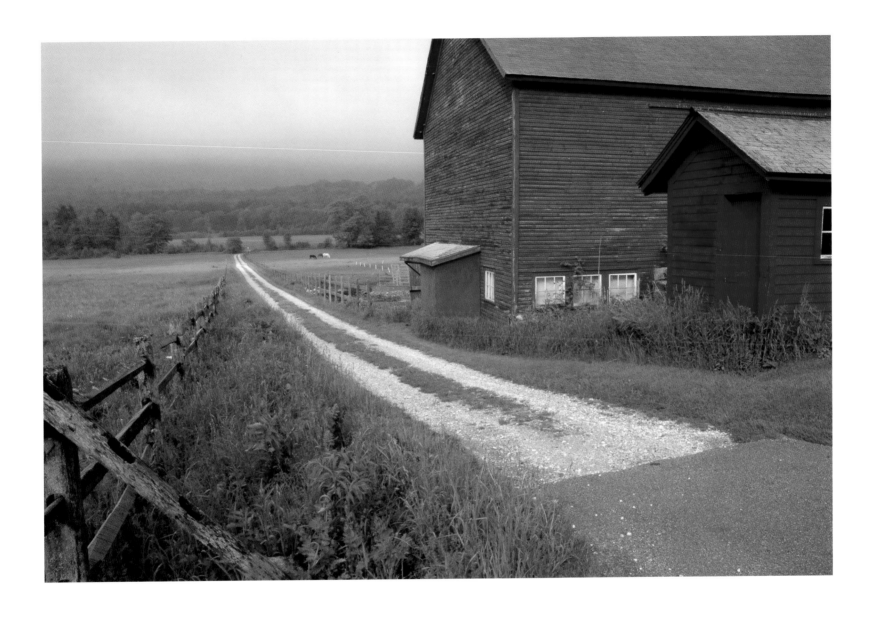

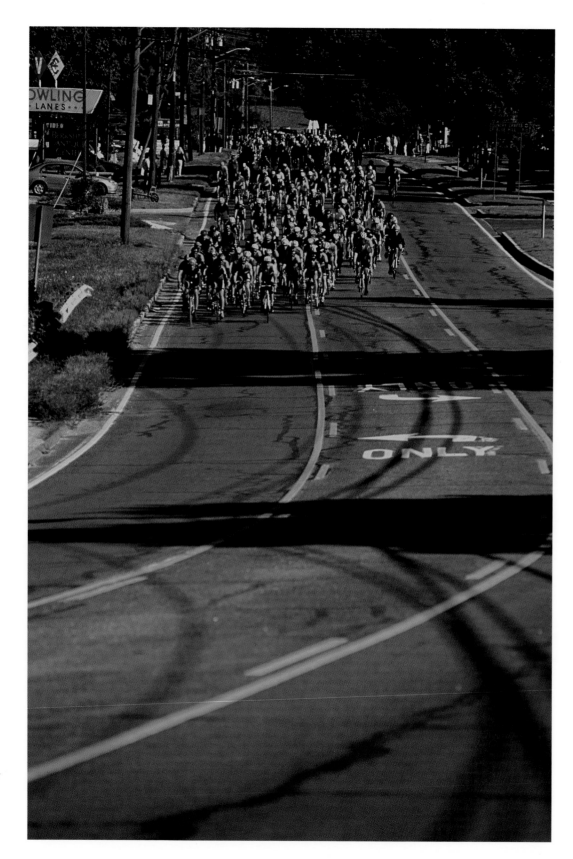

First stage of the Josh Billings Runaground team and individual triathlon on Route 7 in Great Barrington. The race finishes on the grounds of Tanglewood in Lenox.

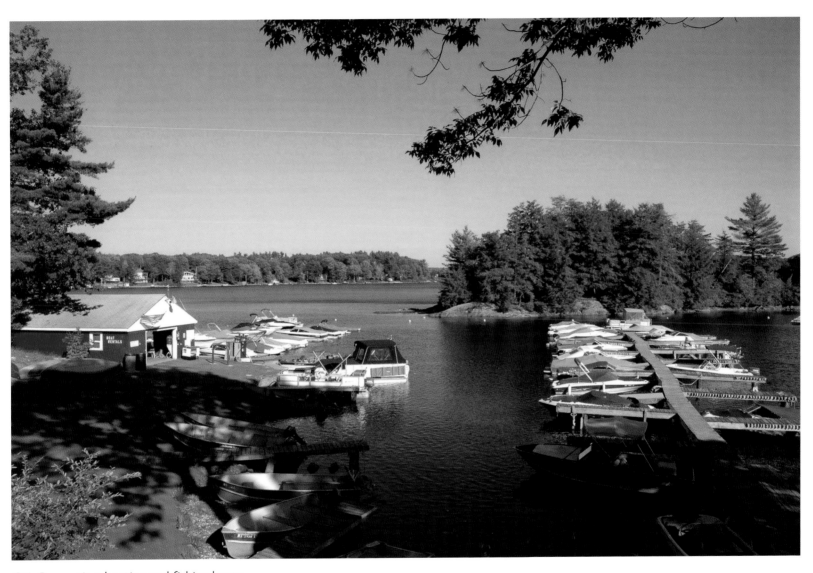

Otis Reservoir, a boating and fishing haven

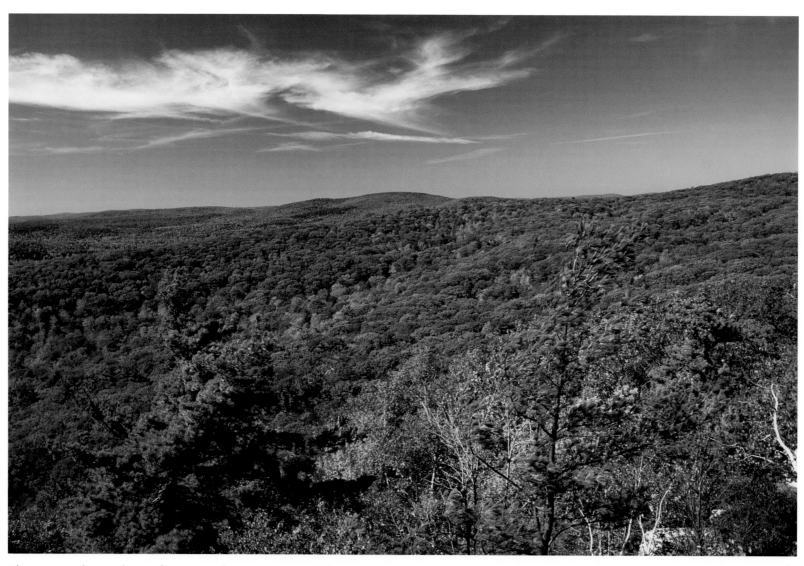

The view to the northwest from Monument Mountain peak on a
clear fall day

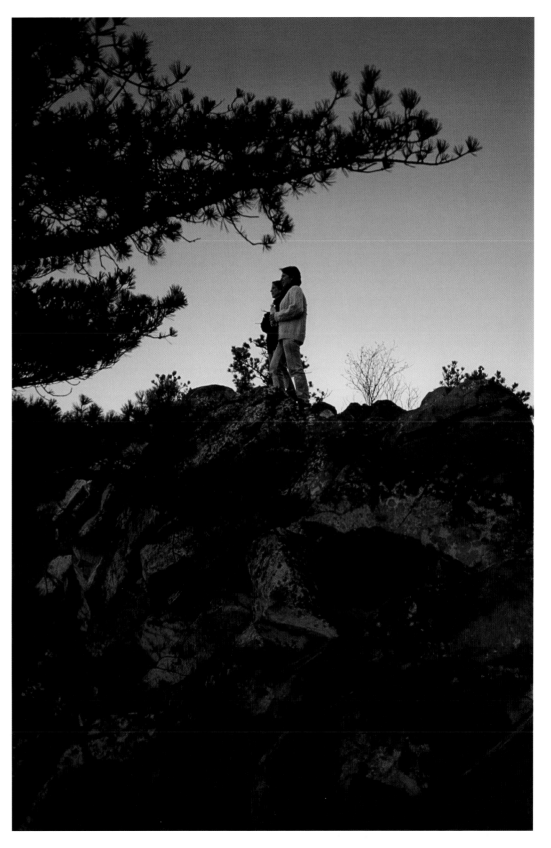

The 360-degree view from
Monument Mountain

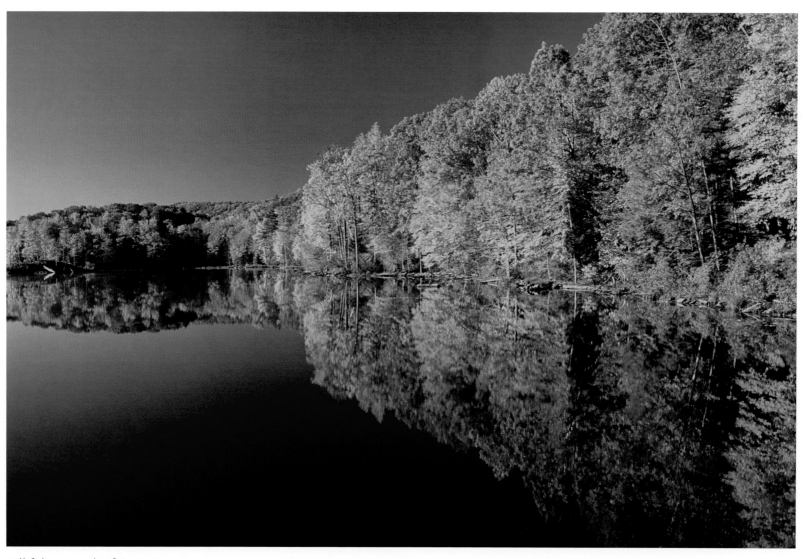

Fall foliage north of Great Barrington

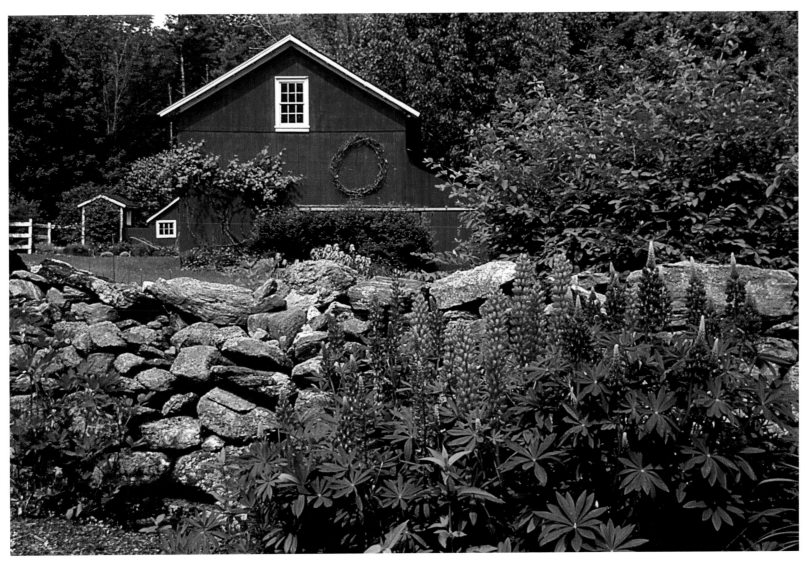

More memories of England along Route 41 north of
Great Barrington

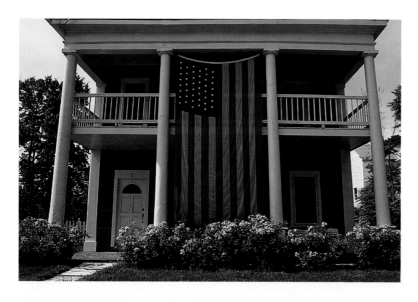

Left: A patriotic display for July Fourth, West Stockbridge

Below: Williams River bridge, Center Street, West Stockbridge

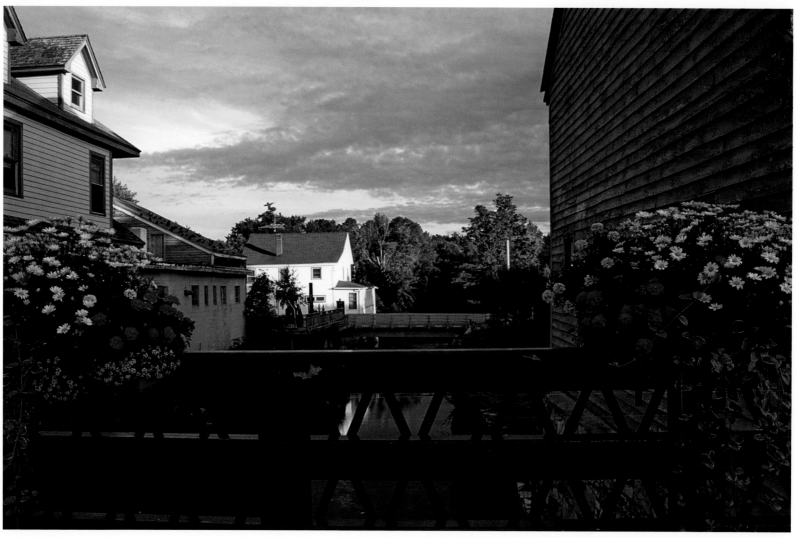

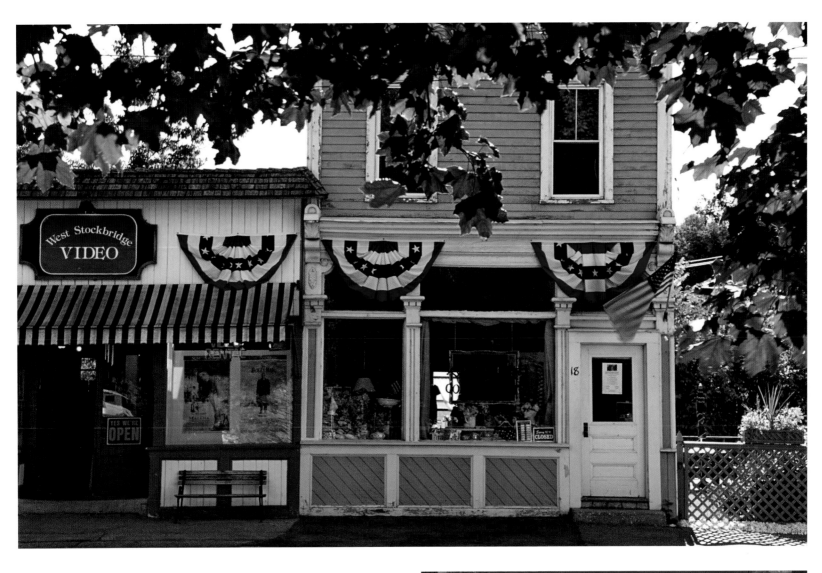

Above: Storefronts, West Stockbridge

Right: Shaker Mill is the most prominent landmark in the center of West Stockbridge.

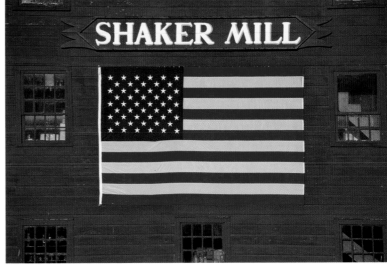

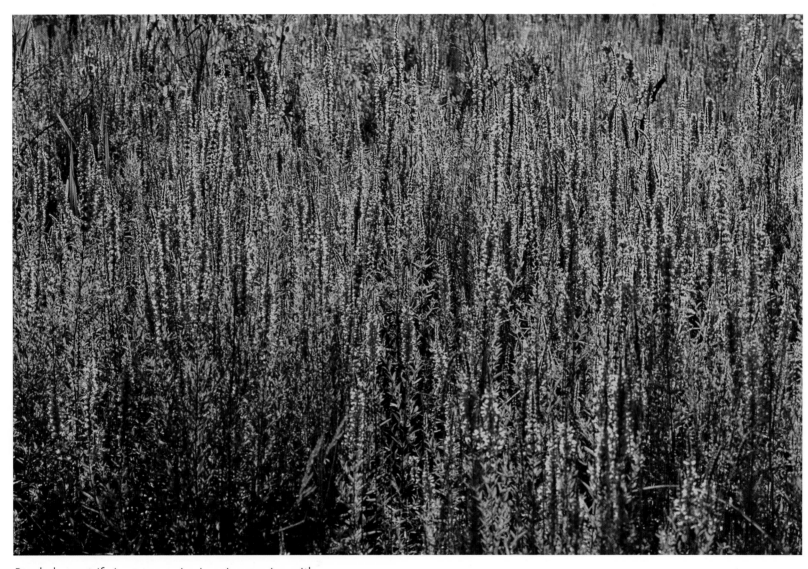

Purple loosestrife is an aggressive invasive species, with a
deceptively beautiful effect on the landscape.

Daybreak over a ridge in Richmond

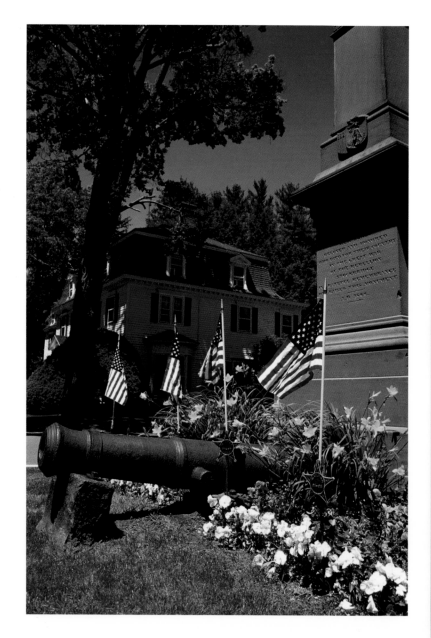

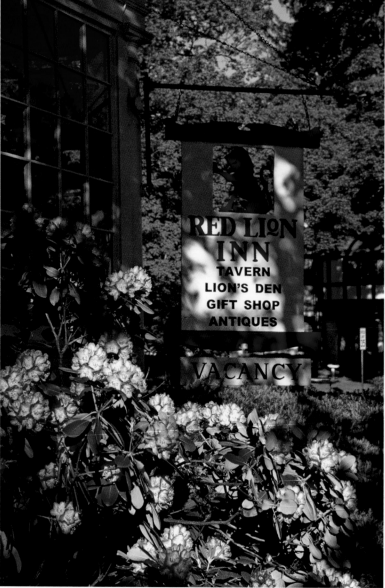

Above: Civil War monument at the principal
crossroads in Stockbridge

Right: The Red Lion Inn, the most renowned
landmark in Stockbridge

84

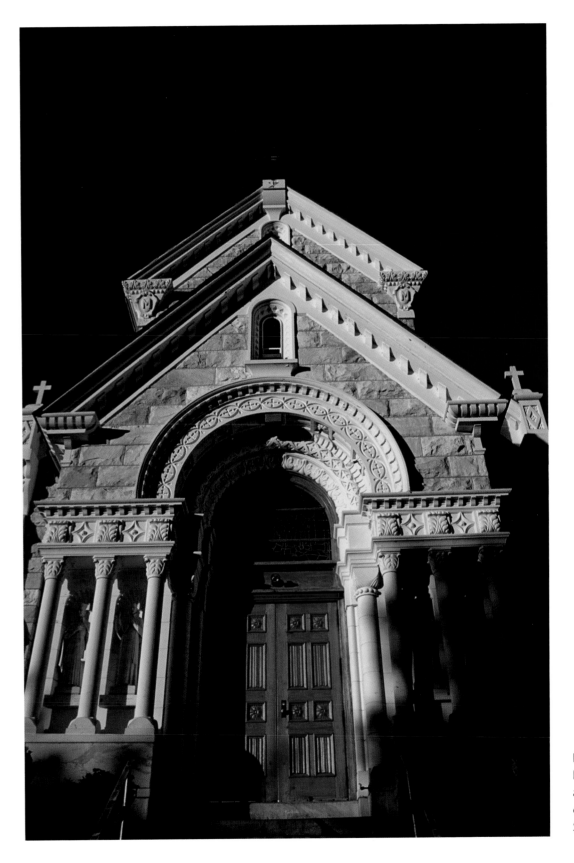

Each year on the Sunday after Easter tens of thousands attend services at the Shrine of the Divine Mercy in Stockbridge.

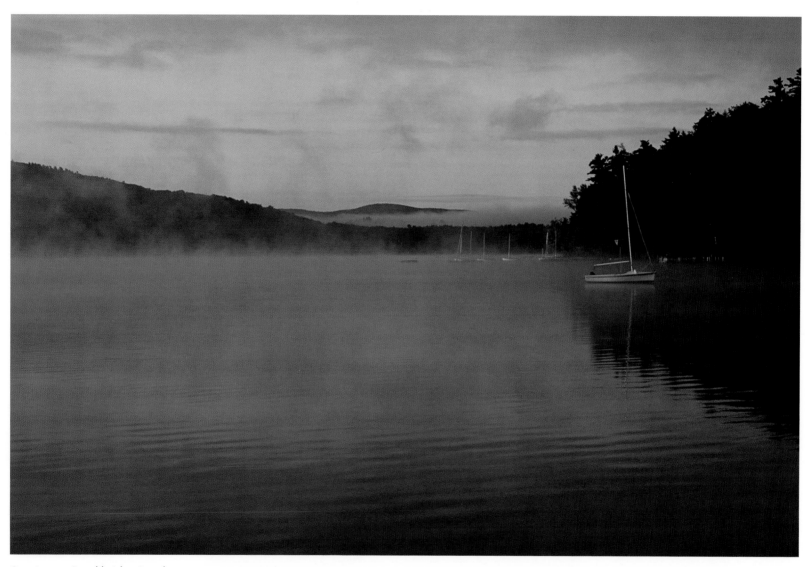

Sunrise on Stockbridge Bowl

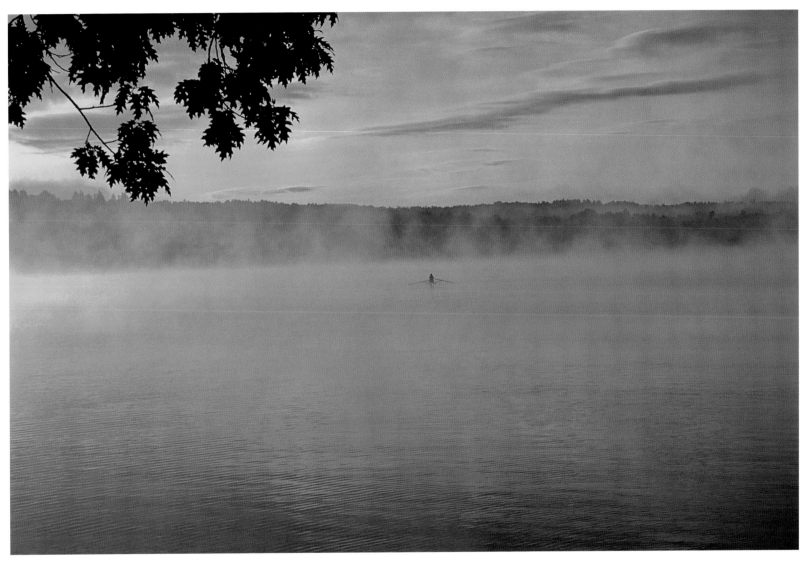

Solitary rower, Stockbridge Bowl

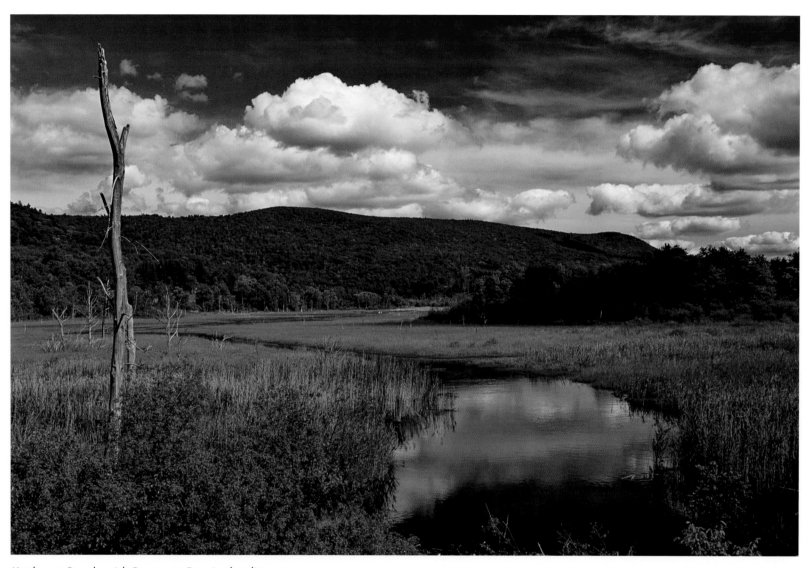

Konkapot Brook, with Burgoyne Pass in the distance

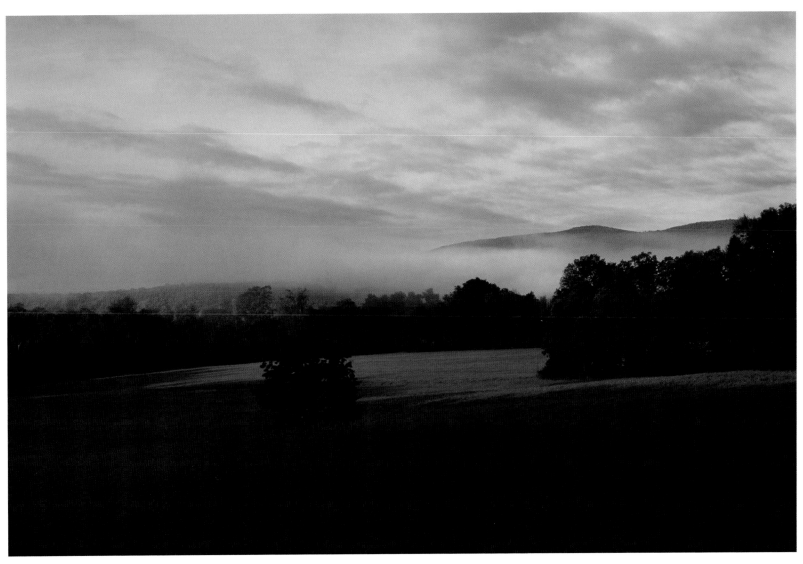

Gould Meadow, just above the north end of Stockbridge Bowl,
with excellent views of the southern mountains

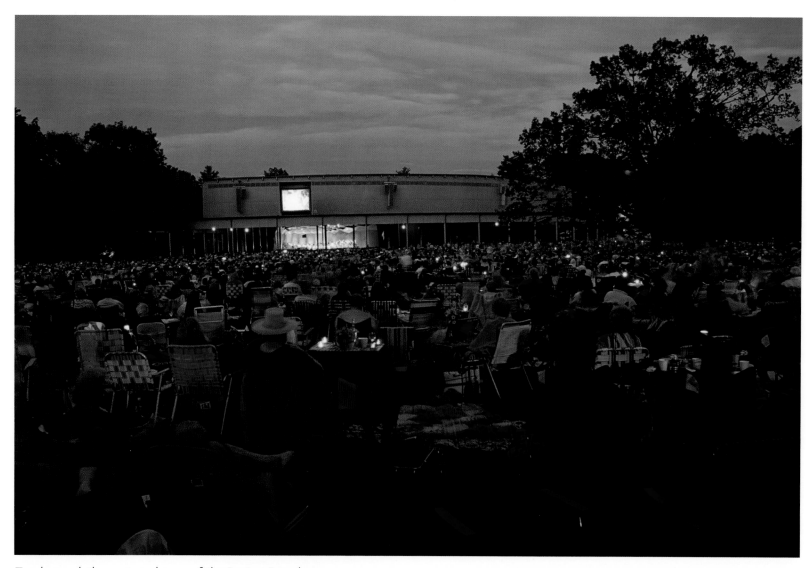

Tanglewood, the summer home of the Boston Symphony
Orchestra, Lenox

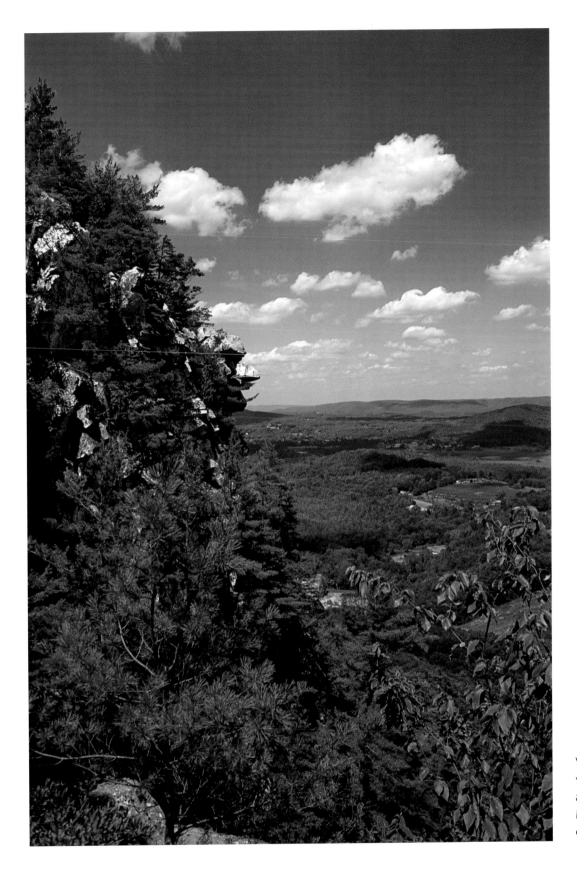

View of the Housatonic River valley north of Stockbridge and Lenox, with October Mountain State Forest in the distance

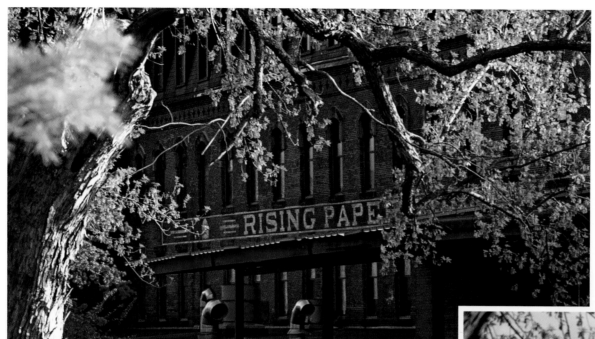

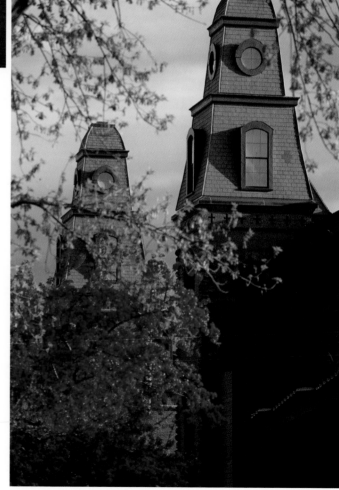

Above and right: Rising Paper Mill, Housatonic

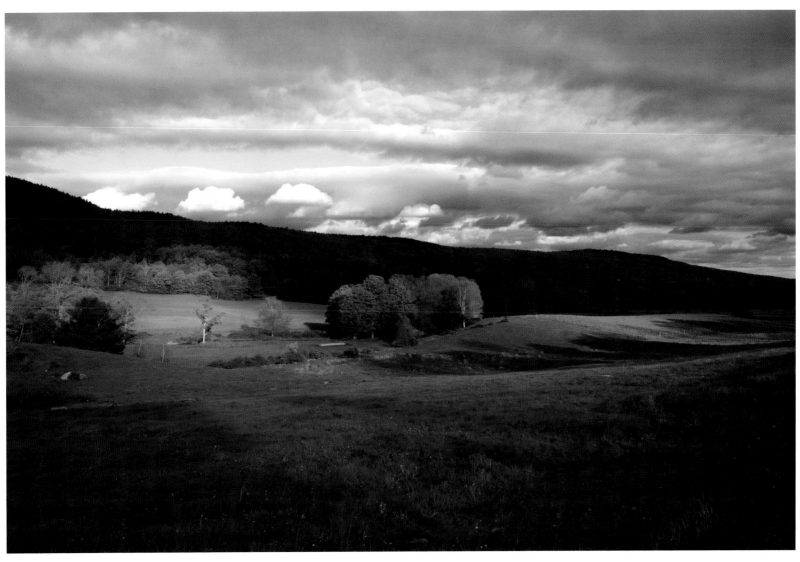

Looking toward East Road, Alford, from West Road

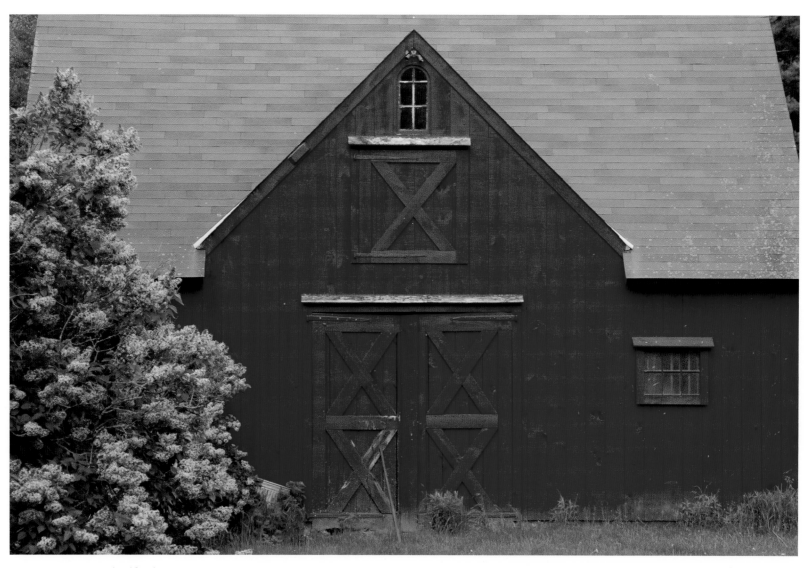

Barn on West Road, Alford

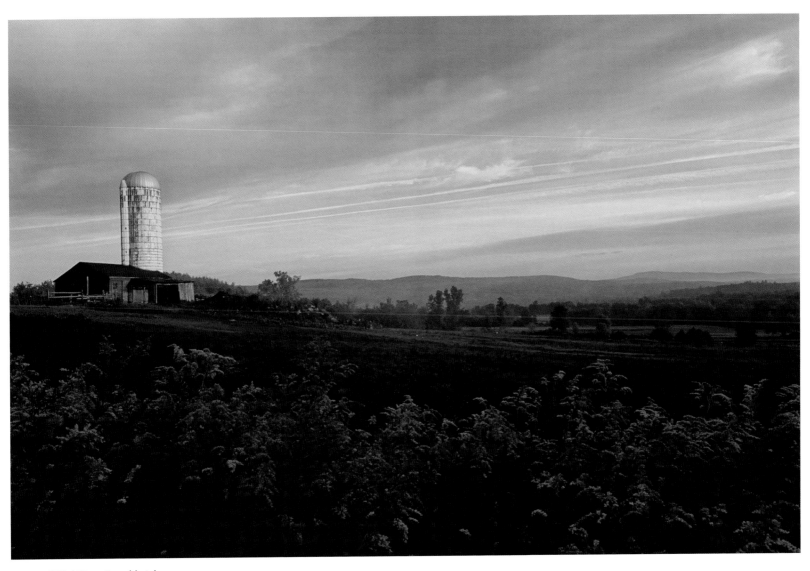

Route 102, West Stockbridge

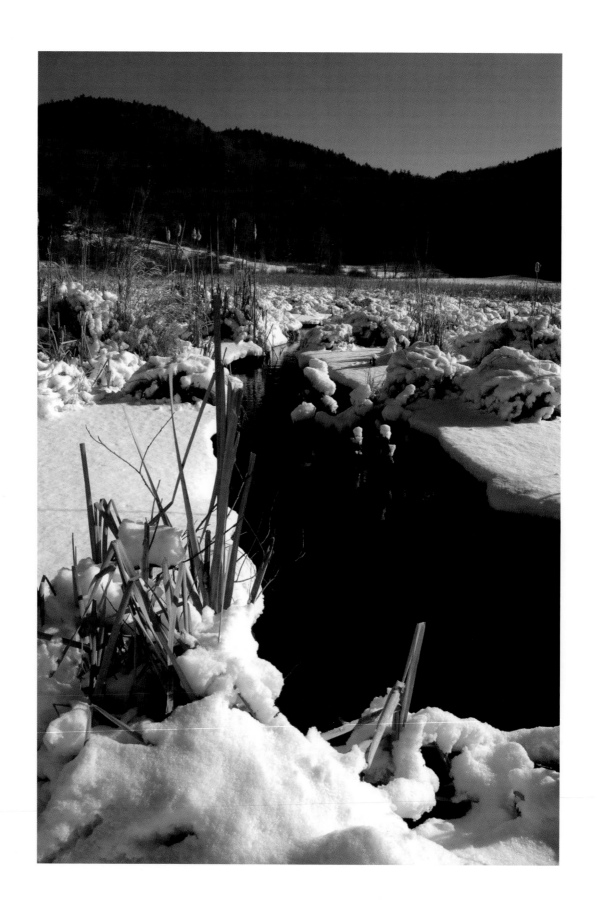

Marshes off Ice Glen Road,
Stockbridge

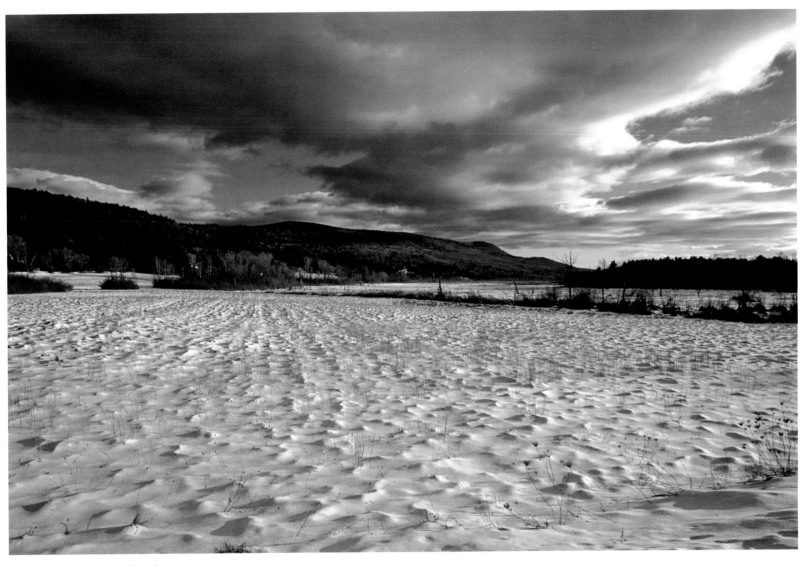

Konkapot Brook, Stockbridge

Naumkeag, a Gilded Age estate on Prospect Hill Road, and now a
popular museum

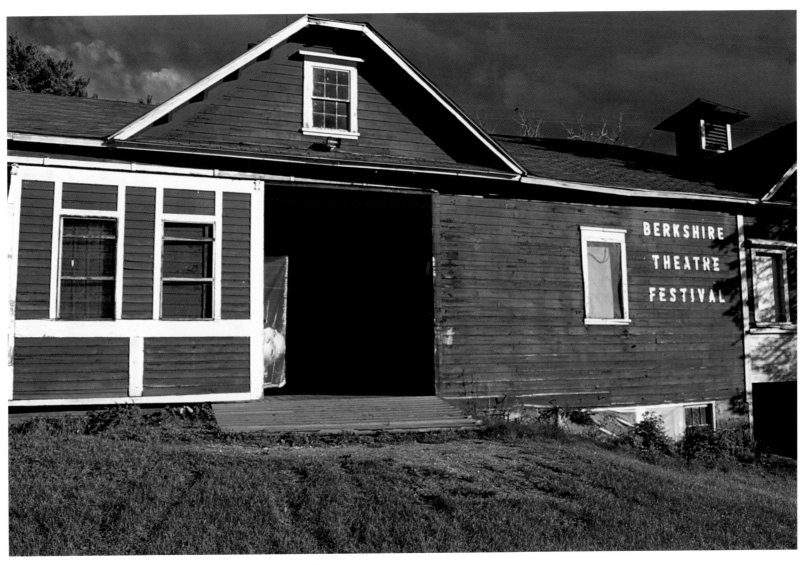

The Berkshire Theatre Festival, founded in 1929, one of the first regional theatres in the country and now the longest-running cultural institution in Berkshire County

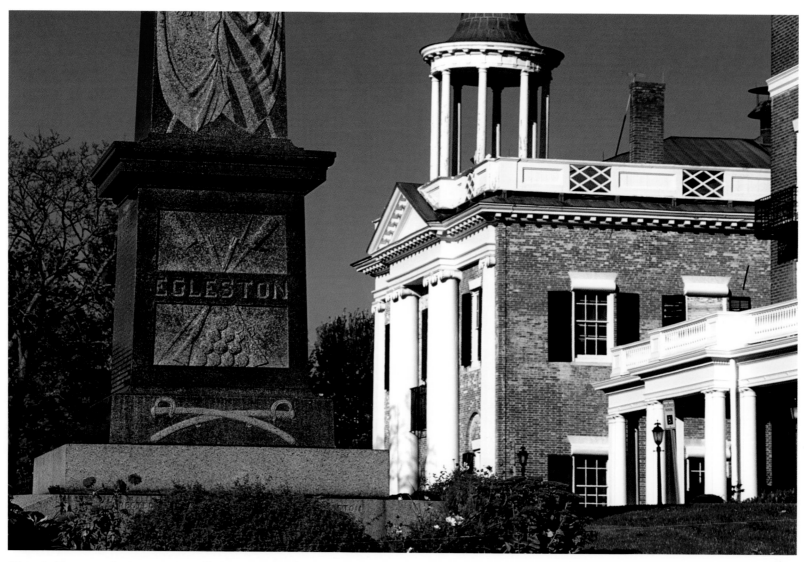

Historic library at the intersection of Main Street and
Route 183, Stockbridge

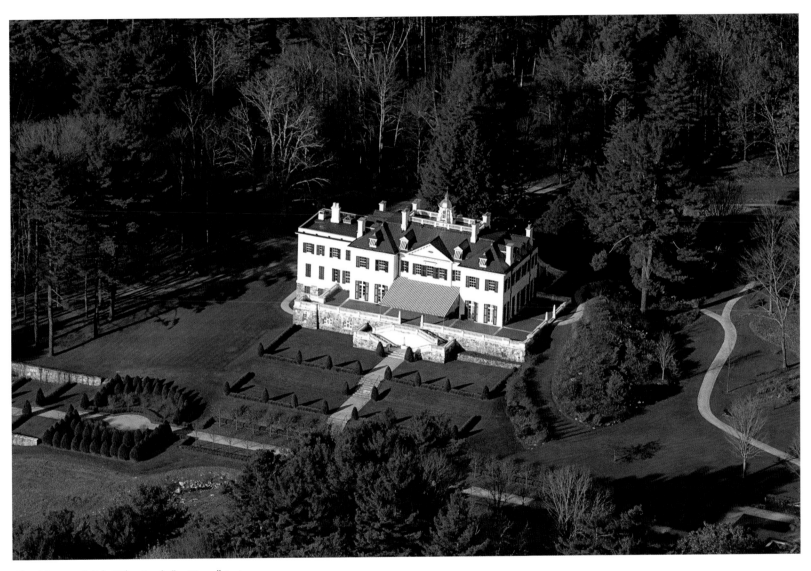

The Mount, Edith Wharton's "cottage" in Lenox

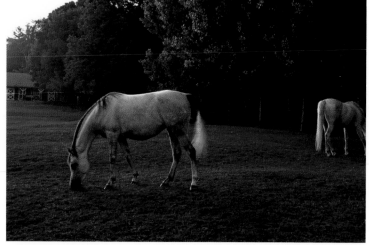

Above: Winter fields, Richmond

Below: Grazing horses, Richmond

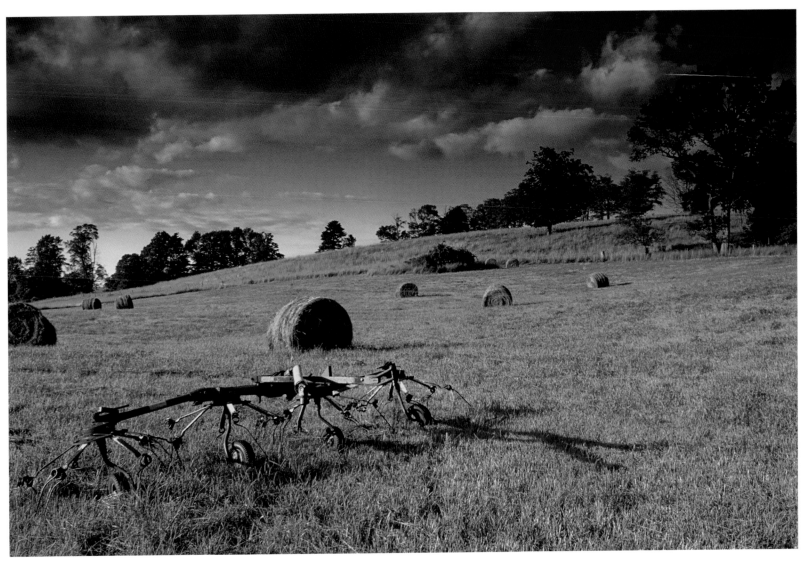

Richmond

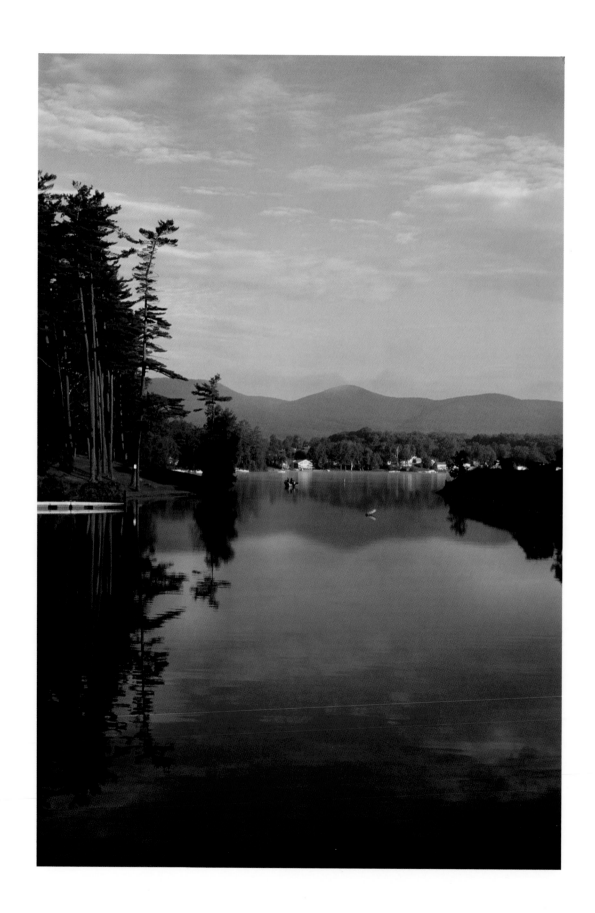

Pontoosuc Lake, source
of the West Branch of
the Housatonic River

Right and below: Pittsfield street art exhibit, summer 2004, commemorating the city's once-vibrant woolens industry

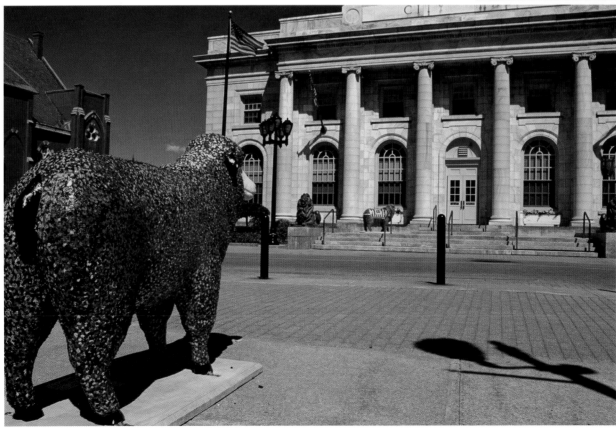

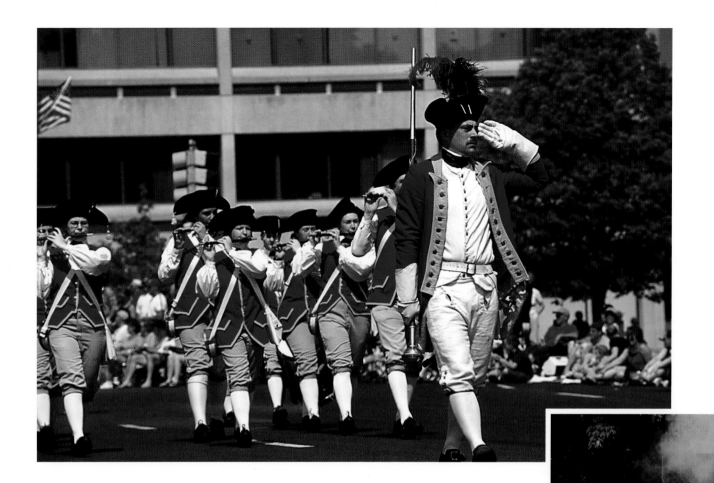

Above, right, and far right: Independence Day parade,
Pittsfield, the county's grandest

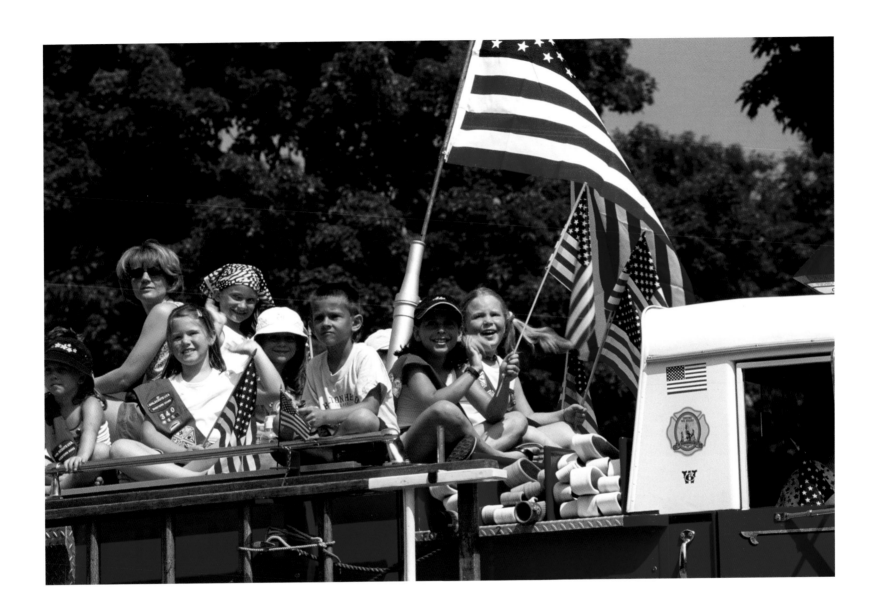

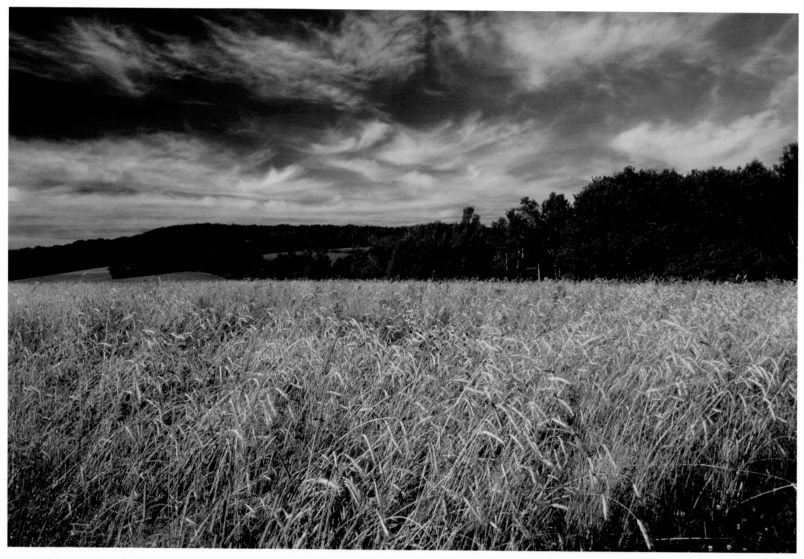

Hay fields, Lanesborough

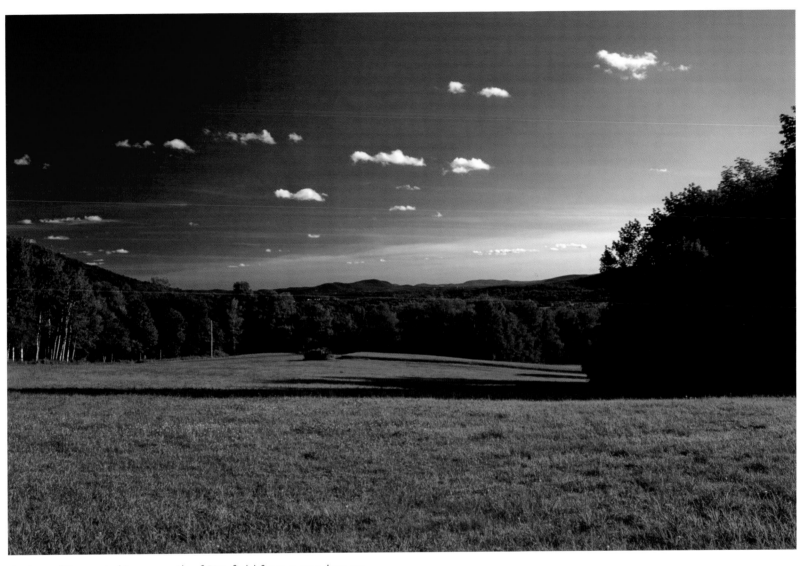

A view of Bosquet ski area south of Pittsfield from a meadow on
the slopes of Mt. Greylock

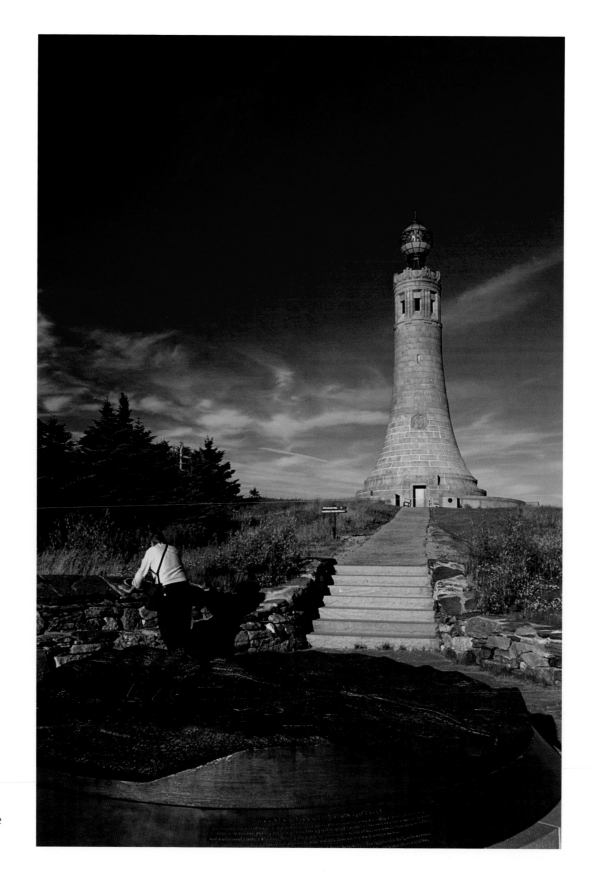

World War I memorial at the summit of Mt. Greylock

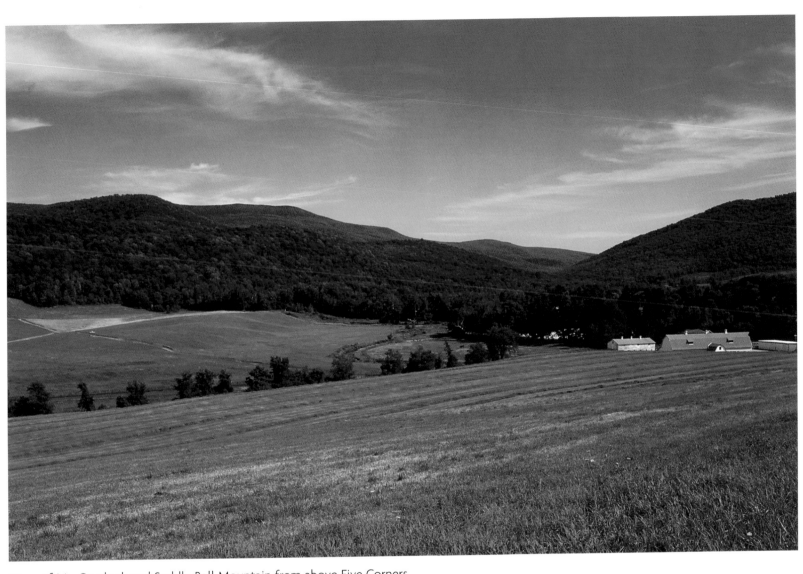

View of Mt. Greylock and Saddle Ball Mountain from above Five Corners
in South Williamstown

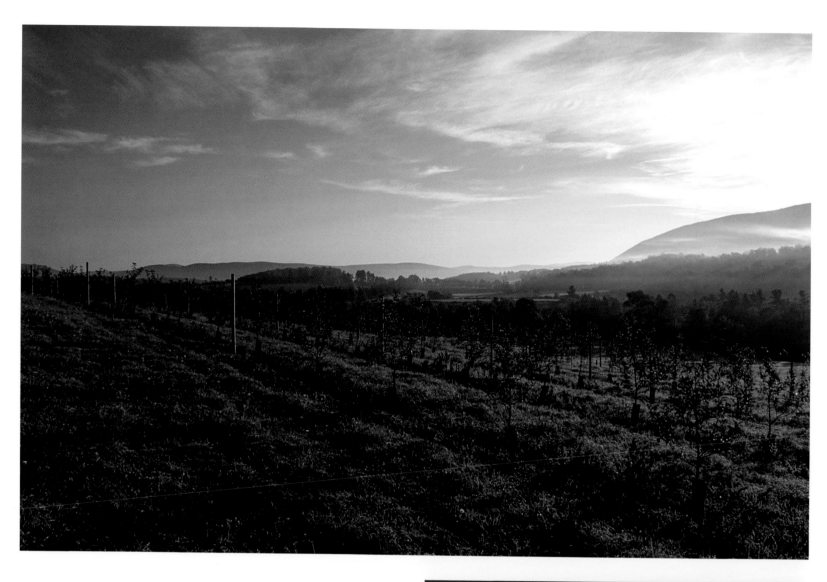

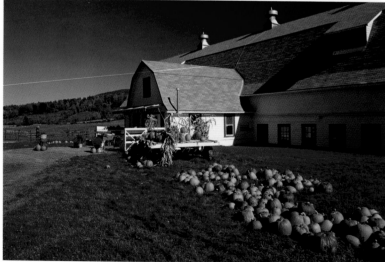

Above: Looking northeast from Five Corners

Right: Barn adjacent to Five Corners

Landscape, Savoy

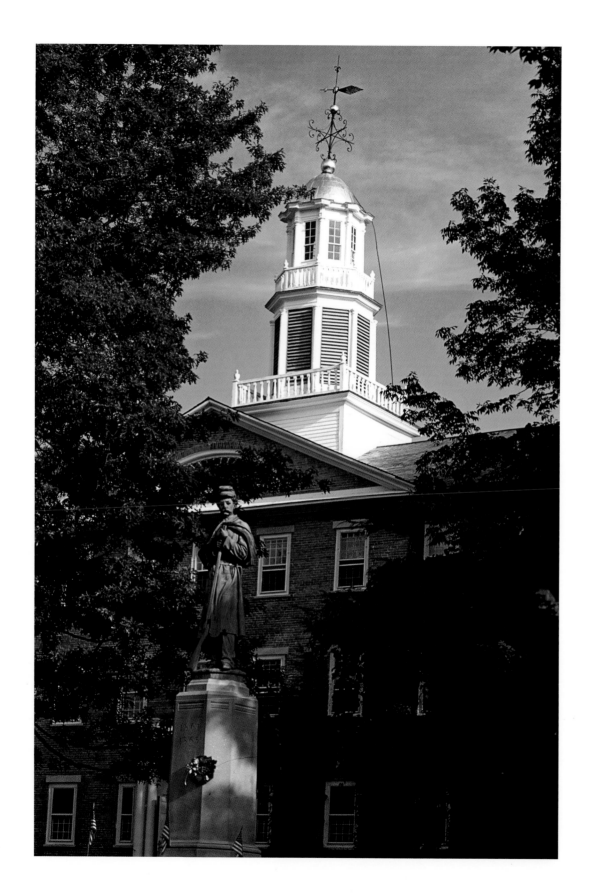

Griffin Hall, Williams College

North of Five Corners

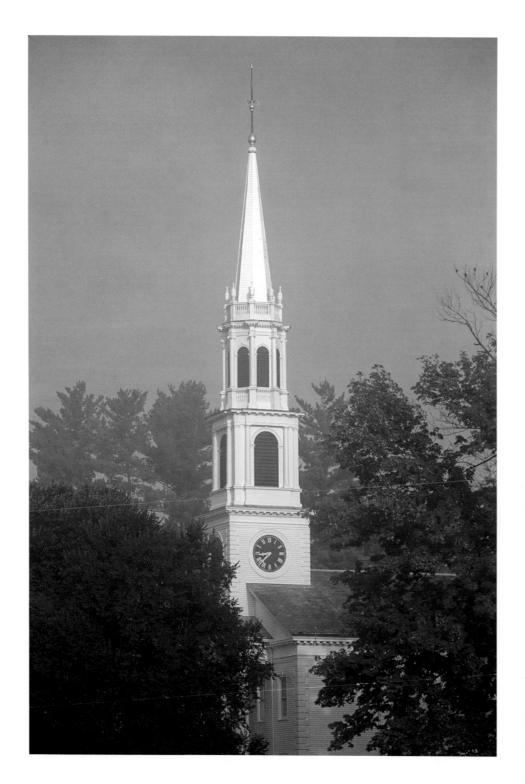

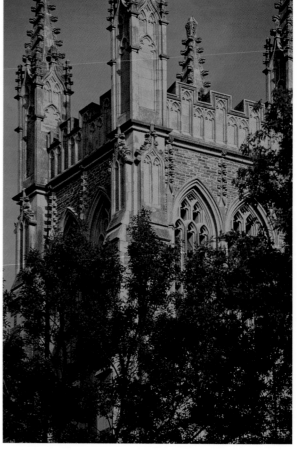

Above: Tower of First Congregational Church, Williamstown

Right: The 1904 Gothic Revival Thompson Memorial Chapel, a center-piece of the Williams College campus

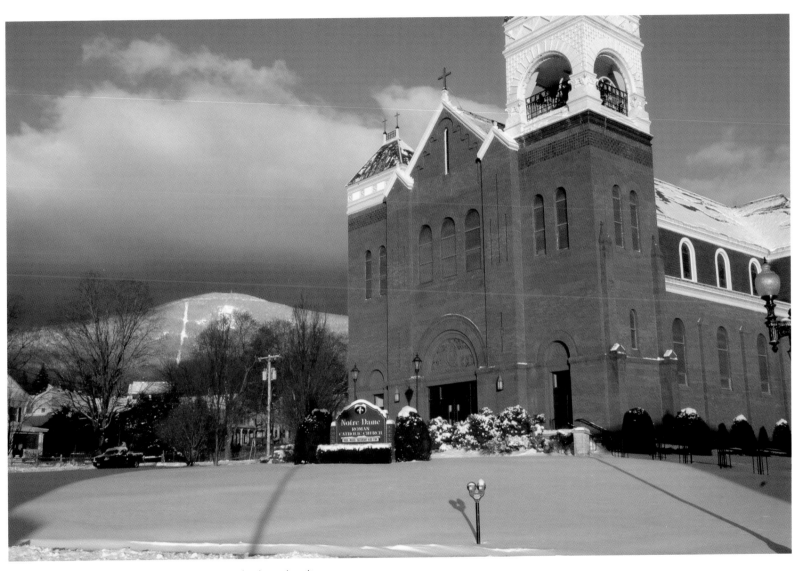

Notre Dame Church, Adams, with Mt. Greylock in the distance

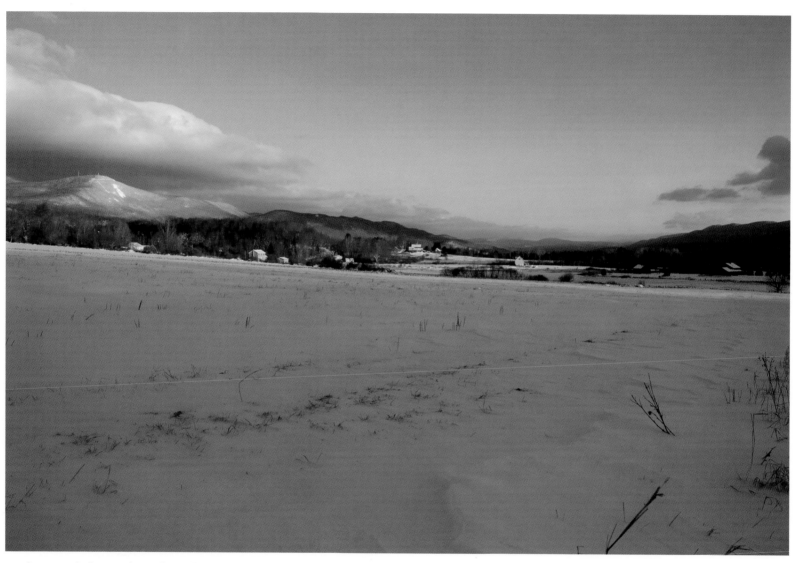

Looking north from Adams through the Hoosic River valley at sunrise

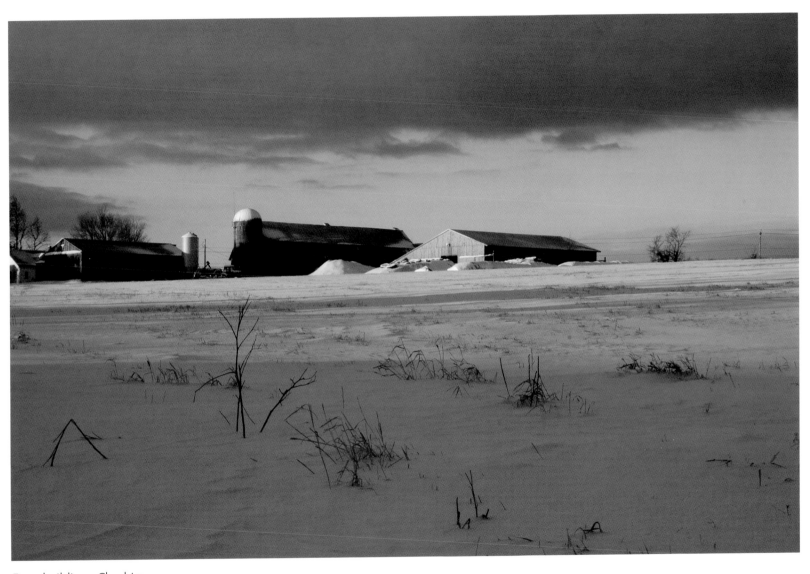

Farm buildings, Cheshire

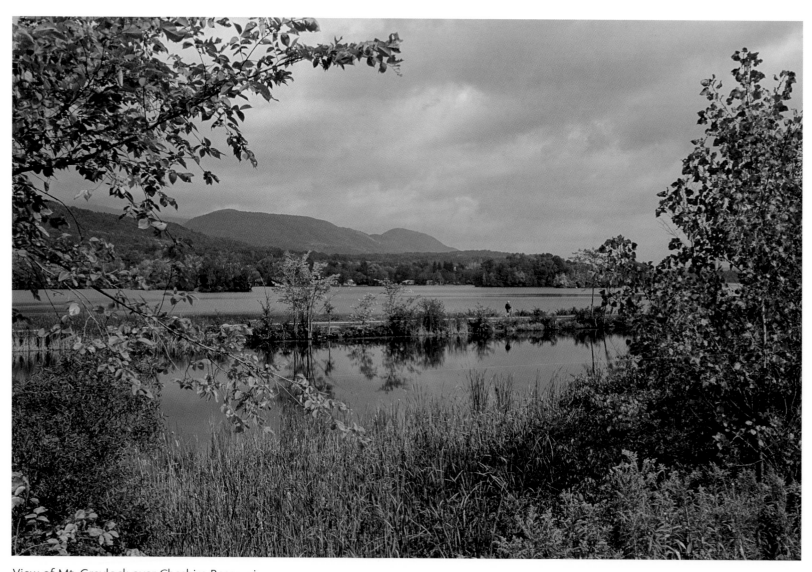

View of Mt. Greylock over Cheshire Reservoir

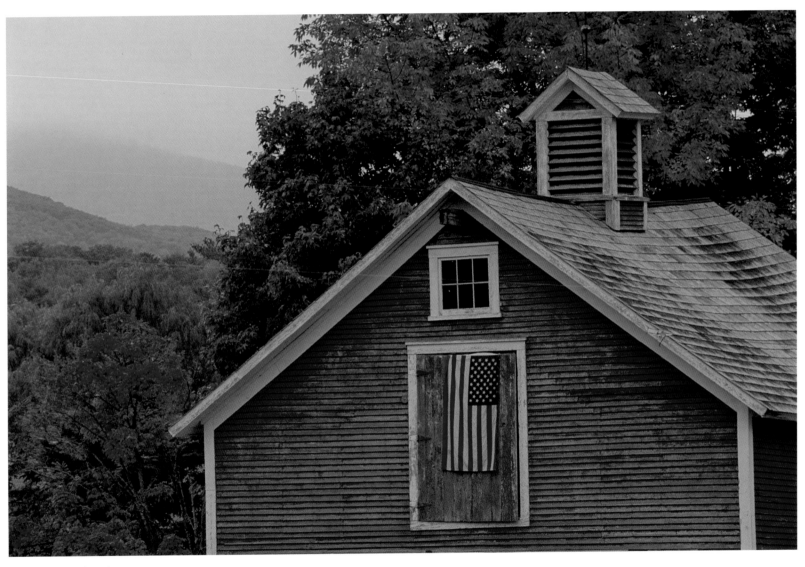

Outside North Adams

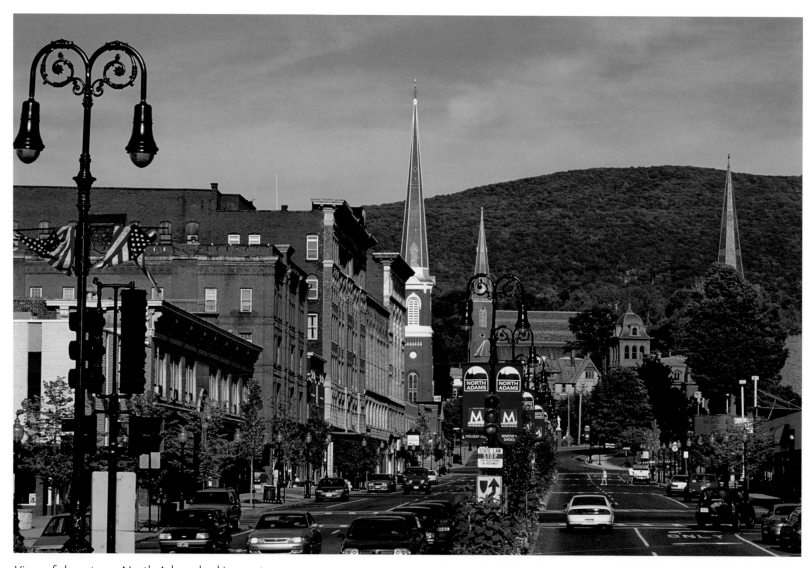

View of downtown North Adams looking east

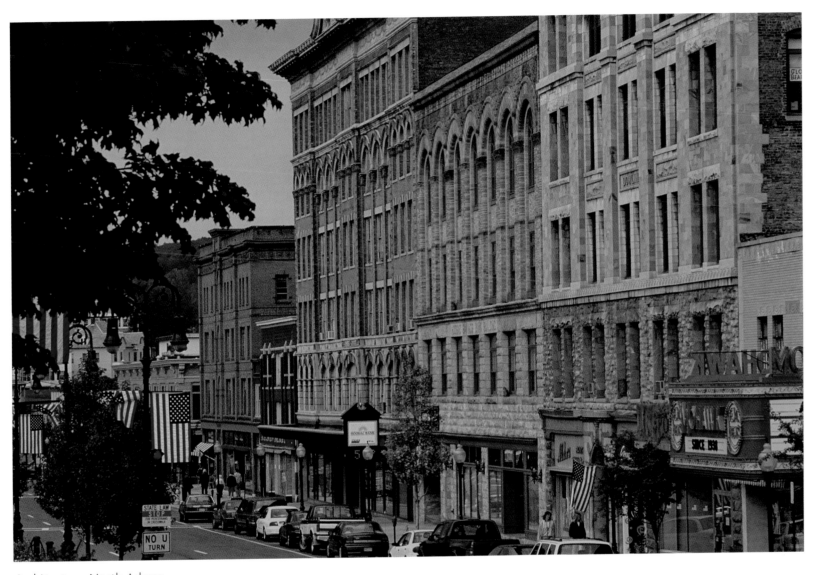

Architecture, North Adams

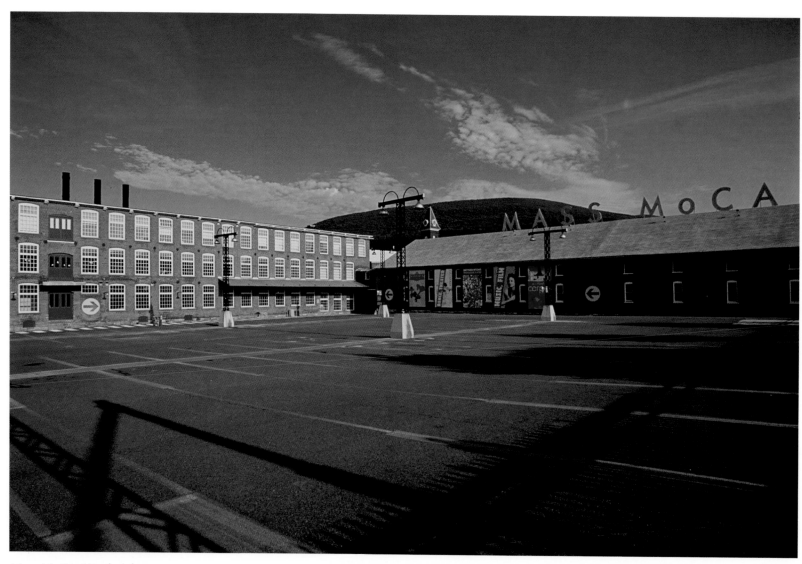

Mass MoCA, North Adams

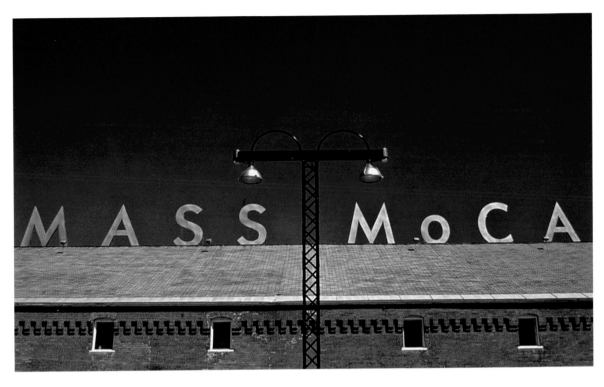

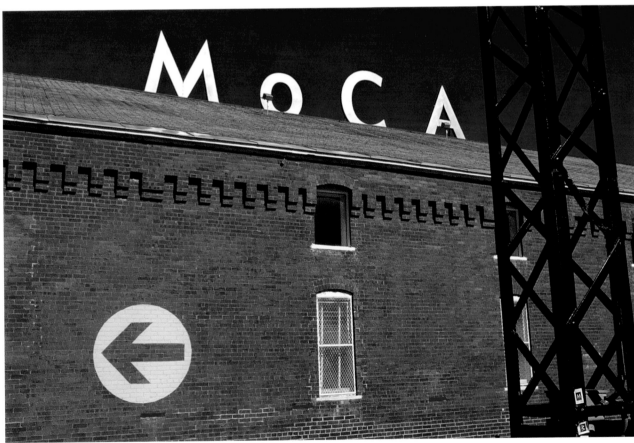

Architectural details,
Mass MoCA

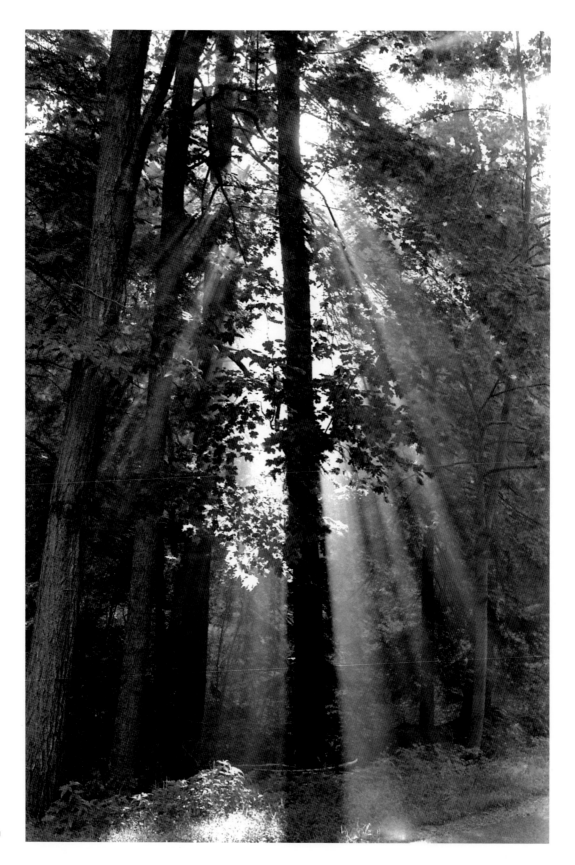

Mt. Greylock State Reservation

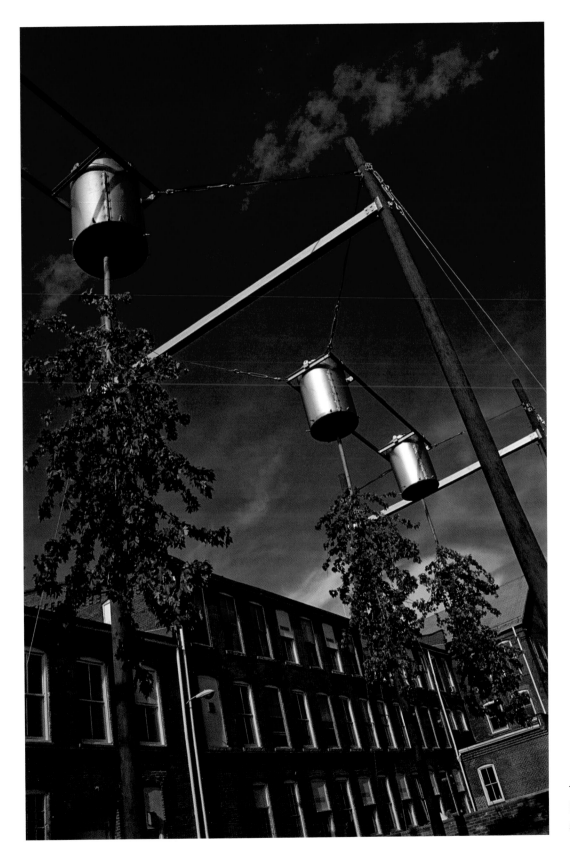

The Tree Logic exhibit has been a part of Mass MoCA since its inception.

STEPHEN G. DONALDSON

A Midwest native, Steve Donaldson spent half his formative years (1969–1975) growing up in England. During this time he witnessed and experienced the world firsthand, traveling to Africa and Eastern Europe, and throughout Western Europe, with his family. Along the way he developed a keen fascination for culture and geography that sustained a lifelong dream to travel the world.

He returned to the United States in time to attend high school in Michigan and then went on to enroll at Ohio Wesleyan University. Graduating with a degree in International Studies in 1983, he spent the next eight years pursuing a Wall Street career in New York City. From there he moved to Los Angeles where he spent five years working in the electronics industry. The tipping point came on a photography trip to Yosemite National Park over Easter weekend 1993. Awed by the scenic beauty, and thirsting for more, he set a date and began to formulate a plan.

Thus, after thirteen years working in the corporate sector, he picked up two cameras and "threw it all away" to pursue his lifelong dream of photodocumenting a journey around the world. From October 1, 1995, until June 2, 1997, he traveled in a great loop around all six inhabited continents. The journey took him from Los Angeles across the United States; through western, central, and eastern Europe; to Scandinavia, Russia, China and central Asia; and on to India and Southeast Asia, Australia, the Middle East, Africa, and South America—all before returning to Los Angeles. In total, he visited forty-two countries and logged in excess of 100,000 miles of back-pack travel. This journey, and the images he compiled over the course of it, was the springboard to a freelance career in photography.

Following the success of an exhibit of his travel images, and countless self-promotional cold calls, Steve caught the attention of a handful of publishers and magazine editors who began to purchase his work for publication. To date his images have appeared in over twenty books as well as a wide variety of magazines and landscape calendars.

As part of his business he conducts a series of highly acclaimed slide-based lecture programs for schools, universities, and professional organizations throughout the United States, which focus on topics including the environment, goal setting, and dream fulfillment.

He continues to travel extensively to remote areas of the world to shoot stock and high-quality editorial images of the world's exotic far reaches. In North America he has compiled thousands of stock images of the eastern states and of Canada's Maritime Provinces. In the Berkshires he also photographs weddings and social events, offers black-and-white portrait packages, produces fine-art photographs, and does a variety of commercial assignment work.

His studio is located in Great Barrington, Massachusetts. Although he credits his love of photography to classes he took in high school, his craft is largely self-taught.